T0059561

FOOD ANATOMY

THE CURIOUS PARTS & PIECES OF OUR EDIBLE WORLD

JULIA ROTHMAN

AUTHOR & ILLUSTRATOR OF FARM ANATOMY & NATURE ANATOMY

WITH HELP FROM RACHEL WHARTON

Storey Publishing

The mission of Storey Publishing is to serve our customers by
publishing practical information that encourages
personal independence in harmony with the environment.

Text and illustrations © 2016 by Julia Rothman

All rights reserved. No part of this book may be reproduced without written permission
from the publisher, except by a reviewer who may quote brief passages or reproduce
illustrations in a review with appropriate credits; nor may any part of this book
be reproduced, stored in a retrieval system, or transmitted in any form or by any
means — electronic, mechanical, photocopying, recording, or other — without written
permission from the publisher.
 The information in this book is true and complete to the best of our knowledge.
All recommendations are made without guarantee on the part of the author or
Storey Publishing. The author and publisher disclaim any liability in connection with the
use of this information.

Storey books are available at special discounts when purchased in bulk for premiums
and sales promotions as well as for fund-raising or educational use. Special editions or
book excerpts can also be created to specification. For details, please call 800-827-8673,
or send an email to sales@storey.com.

Storey Publishing
210 MASS MoCA Way
North Adams, MA 01247
storey.com

Printed in China by R.R. Donnelley
10 9 8 7 6

Library of Congress Cataloging-in-Publication Data

Names: Rothman, Julia, author. ı Wharton, Rachel, author.
Title: Food anatomy : the curious parts & pieces of our edible world / by Julia Rothman ;
 with help from Rachel Wharton.
Description: North Adams, MA : Storey Publishing, [2016] ı Includes bibliographical
 references and index.
Identifiers: LCCN 2016039999 (print) ı LCCN 2016047165 (ebook) ı ISBN 9781612123394
 (paper with flaps : alk. paper) ı ISBN 9781612123400 (ebook)
Subjects: LCSH: Food. ı Cooking.
Classification: LCC TX355 .R6717 2016 (print) ı LCC TX355 (ebook) ı DDC 641.3—dc23
LC record available at https://lccn.loc.gov/2016039999

For Sunny, who taught me to eat a real breakfast of poached eggs and avocado, who makes the best lentil soup, who can toss pizza dough like a pro, and who led me through the Finnish forest for chanterelles. Thank you for all the tasty adventures.

CONTENTS

My parents always cooked a full dinner for me and my sister after they came home from work. When I think back to it now, I am in awe of their dedication to our family meals. We sat around a large round oak table at six o'clock and talked and ate. It was sesame peanut noodles, or breaded tofu, or my favorite, noodle pudding (a passed down Jewish kugel recipe, see page 95) or my dad's favorite, beer-can chicken. (We were always subjected to viewing the chicken body sitting upright on the can. To my dad, that ridiculous image never got old.) My job was usually to set the table, or clear the table, or make the salad. I didn't have much interest in helping my parents cook aside from making easy omelettes and pancakes some mornings.

In college I was poor. I remember buying a huge carton of individually packaged Cup o' Noodles from Costco for quick, cheap meals and overfilling my plate at the dining hall when I had points left on my card. After college when I moved to Brooklyn and started making some money, I ate out all the time. In one block of my neighborhood, you could take an inexpensive food tour around the world from Israel to Vietnam to Greece just a few doors down the street. When the automatic food ordering apps came around a few years ago, I could click checkout and twenty minutes later there was food at my door- falafel with red cabbage slaw, a spicy tofu Bahn Mai sandwich or a big Mediterranean salad with stuffed grape leaves and lebni on the side.

I gained an interest in food around the time I started working on my first book in this series, Farm Anatomy, about seven years ago. I stopped eating meat and paid more attention to seasonal fruits and vegetables. I began shopping more at the farmer's market near my apartment in Grand Army Plaza, and buying more organic and locally grown produce. This meant I had to cook more, or at least prepare more food. I got rid of my microwave and bought a fancy Japanese knife. I took a cooking class at the International Culinary Center in vegan cooking and learned a few techniques. (Though I mistakenly grated a bit of my finger into one of the dishes so it wasn't technically vegan!).

I am still very much a beginner cook, but I am not a beginner at eating. This book gave me a chance to explore that further. I tried to taste most of the things I drew. I went to a variety of Asian markets and came home to puree Chinese yams into pancakes and grate real fresh wasabi root. I tasted dragonfruit and horned melon, but I couldn't bring myself to eat durian. (I opened it just a crack to see what the smelly fuss was all about. I attempted, and failed to bring even a tiny piece close to my face. Instead, I laughed hysterically and practically gagged at the intense odor.)

The trips I took while working on this book became chances to try more dishes. In Amsterdam I sampled dozens of cheeses, some aged in bunkers for years, and paired them with beers brewed in an old windmill. In Uganda, I had matoke and enjoyed Rolexes (eggs rolled up in chapati) for breakfast. In Finland, I learned to make traditional rye bread from a hundred-plus-year-old root. I carved my own mixing tool from a spruce tree to use on the dough. I visited a strawberry plantation and picked the sweetest strawberries I've ever tasted (the long days full of sunshine make them exceptional.) In the winter I foraged through the snow-covered forest for chanterelles that made their way onto a pizza for a New Year's Eve celebration.

This past Thanksgiving was my biggest cooking achievement to date. I invited my parents and sister to my tiny Brooklyn apartment to celebrate the holiday. Over the phone, my mother pleaded, "Are you sure? No turkey? Why don't I make one and bring it just in case?" I assured her it would be great, though I hadn't fully convinced myself yet. I prepared a menu of coconut milk-based lentil soup, kale and farro salad, creamy potatoes, roasted kabocha squash, sriracha-coated Brussels sprouts and sweet potato pie for dessert. Miraculously, the comments coming from my family were "wow, this is actually really delicious" and "better than regular Thanksgiving."

My writing partner was Rachel Wharton. Her expertise in the culinary world made up for everything I am still learning. She shared her knowledge and researched what she didn't know. We tried to cover a range of topics on everything we could think of. But that is always impossible and this is only a small taste of what we thought would be interesting to collect and draw.

You wouldn't believe how hungry I got working on this book. As I looked back at my photos or searched the Internet for good references of meals to draw, I immediately had to run to my fridge and try and replicate the food. Cravings were unbearable and I am excited to have finished this book so I can lose the weight I gained making it.

I hope this book will inspire you to experiment with more cooking, be more curious about what you're eating, and go on more food adventures as I will continue to do. Cheers!

Julia Rothman

Kuuslahti Strawberry Farm in Rautalampi, Finland

GOUACHE
SHELL PINK

GOUACHE
AQUA BLUE

WINSOR & NEWTON
Designers
GOUACHE

STRAWB
PLAN

CHAPTER 1

Food for Thought

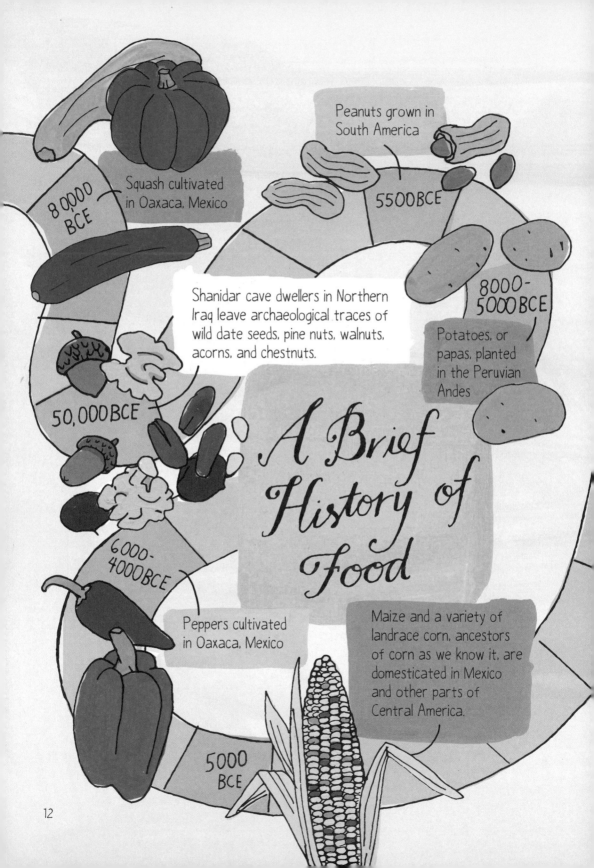

A Brief History of Food

Squash cultivated in Oaxaca, Mexico

80,000 BCE

Peanuts grown in South America

5500 BCE

Shanidar cave dwellers in Northern Iraq leave archaeological traces of wild date seeds, pine nuts, walnuts, acorns, and chestnuts.

8000–5000 BCE

Potatoes, or papas, planted in the Peruvian Andes

50,000 BCE

6000–4000 BCE

Peppers cultivated in Oaxaca, Mexico

Maize and a variety of landrace corn, ancestors of corn as we know it, are domesticated in Mexico and other parts of Central America.

5000 BCE

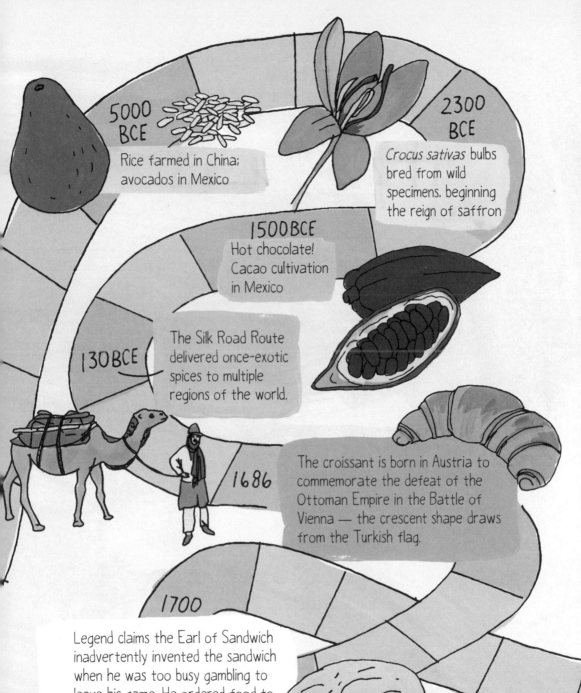

5000 BCE Rice farmed in China; avocados in Mexico

2300 BCE *Crocus sativas* bulbs bred from wild specimens, beginning the reign of saffron

1500 BCE Hot chocolate! Cacao cultivation in Mexico

130 BCE The Silk Road Route delivered once-exotic spices to multiple regions of the world.

1686 The croissant is born in Austria to commemorate the defeat of the Ottoman Empire in the Battle of Vienna — the crescent shape draws from the Turkish flag.

1700 Legend claims the Earl of Sandwich inadvertently invented the sandwich when he was too busy gambling to leave his game. He ordered food to the table and put it between two pieces of bread.

1773

After the Boston Tea Party, many Americans switched to coffee from tea in a show of patriotism.

1763

The first oyster saloon in the American colonies opened in a New York City cellar on Broad Street.

1845-1852

Irish Potato Famine (also known as The Great Famine) struck Ireland leaving about 1 million dead, and forcing another million to emigrate from the country.

1880

"Chow Chop Suey" - a Chinese-style American dish made with odds and ends – onions, bamboo shoots, and bean sprouts – gained favor amongst hipsters of the day of New York City. Soon Mott Street becomes a popular destination for Chinese food.

1904

The ice cream cone is invented at the St. Louis World's Fair.

1908

At New York City's first pizzeria, pies cost 5 cents, which many people can't afford.

1923

Caesar Cardini creates his namesake salad at his Tijuana restaurant — adding a splash of showmanship with table-side preparation.

The publication of *Mastering the Art of French Cooking* and Julia Child's subsequent PBS cooking show change the way Americans think about cooking.

MASTERING THE ART OF French Cooking

By SIMONE LOUISETTE JULIA CH

1928

Sliced bread becomes the perennial next-best-thing ever invented.

1961

1966

The first sushi restaurant in America opens in southern California, but it takes a decade before American-style sushi, like the California Roll, becomes popular.

1986

The slow food movement is founded in Italy with a dedication to encouraging eco-friendly local farming and eating fresh, seasonal produce.

A FEW TASTY
WORDS TO KNOW

acerbic. sour, bitter, or having an acidic flavor

ambrosial. having an exceptionally satisfying taste and/or smell

brackish. salty tasting

delectable. exquisitely delicious and delightful, luscious

dulcet. having a gentle sweetness

fetid. smelling awful and unpleasant

flavor. the sensation detected via mouth and nose combining taste, texture and aroma

gamy. having the flavor or aroma of game, often connotes a slightly spoiled quality

heat. Referring to the amount of spice in food

mature. fully developed or reaching a desired state

palatable. an okay taste, not particulary amazing but not awful

piquant. a spicy and sharply stimulating flavor

rich. full-bodied, heavy, robust; often used to describe overly buttery food

saccharine. overly sweet or syrupy

sharp. a strong bitter flavor

toothsome. delicious and appetizing, often tasty, healthy and fresh

umami. one of the five basic flavor profiles besides sweet, sour, bitter and salty; a pleasantly round, savory flavor

unctuous. oily-tasting, containing a rich slipperiness

woodsy. earthy, dirt-like taste, like mushrooms

PLACE SETTINGS

Formal American

Eat to the left, drink to your right.
Then begin with the fork, knife, or
spoon farthest away from your plate.

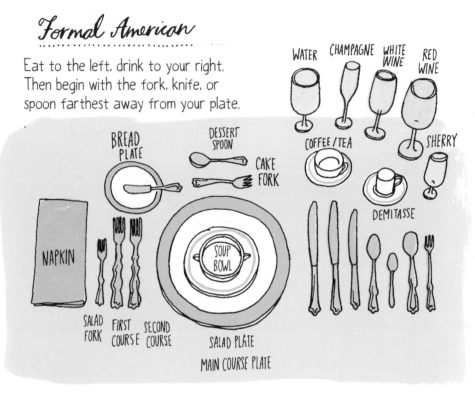

WATER CHAMPAGNE WHITE WINE RED WINE

BREAD PLATE DESSERT SPOON COFFEE/TEA SHERRY

CAKE FORK

DEMITASSE

NAPKIN SOUP BOWL

SALAD FORK FIRST COURSE SECOND COURSE SALAD PLATE

MAIN COURSE PLATE

Chinese

Leaving a bit of food
on your plate
indicates to your
hosts that they have
provided more than
enough food.

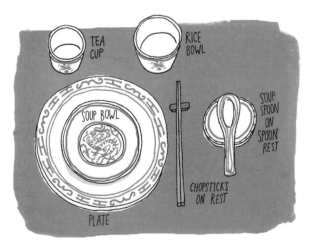

TEA CUP RICE BOWL

SOUP BOWL SOUP SPOON ON SPOON REST

CHOPSTICKS ON REST

PLATE

Japanese

Dishes are only partly filled, so as not to obscure the design of the serving vessel, and chopsticks are placed directly in front of each diner. In the meal itself, the balance of color, cooking techniques, and the five senses (sweet, salty, sour, etc.) are always taken into consideration.

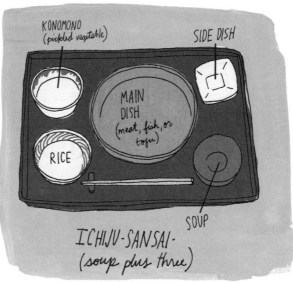

KONOMONO (pickled vegetable)

SIDE DISH

MAIN DISH (meat, fish, or tofu)

RICE

SOUP

ICHIJU-SANSAI· (soup plus three)

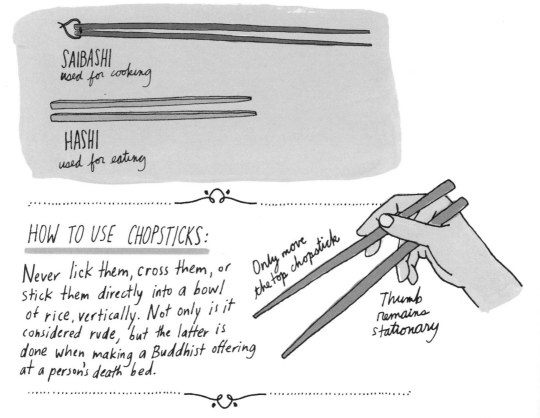

SAIBASHI
used for cooking

HASHI
used for eating

HOW TO USE CHOPSTICKS:

Never lick them, cross them, or stick them directly into a bowl of rice, vertically. Not only is it considered rude, but the latter is done when making a Buddhist offering at a person's death bed.

Only move the top chopstick

Thumb remains stationary

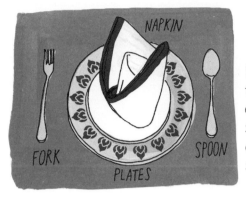

NAPKIN

FORK

SPOON

PLATES

Thai

Forks are used only to push food into the spoon, the primary utensil. Elders eat first, and meals are always shared. Even if the food is super delicious, leave a little on your plate to show that the meal was generous.

Korean Table

A traditional meal includes *banchan*, shared side dishes like marinated vegetables or kimchi. Diners usually have their own bowls of rice, and each person uses their spoons and chopsticks to serve themselves from the small plates on the table.

Indian/Nepalese

THALI

Traditionally, food is eaten with the right hand. It's considered unclean to use your left. This is a common practice in India, parts of the Middle East, and some parts of Africa.

TRAY

KATORI DISH

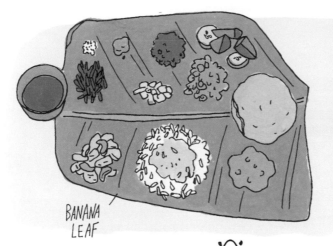

BANANA LEAF

Some families eat seated on the floor, from a large banana leaf that has a little bit of all the dishes laid out before diners.

HOW TO EAT WITH YOUR FINGERS:

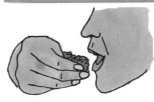

- only use your right hand
- only use your fingers, not the palm of your hand
- use your thumb to push the food into your mouth
- tear breads with your thumb and finger (just right hand)

KINDS OF FORKS

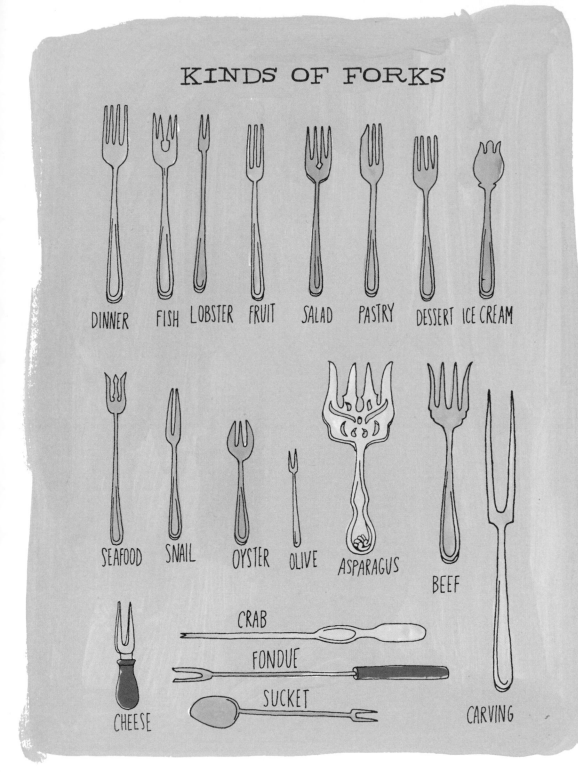

DINNER FISH LOBSTER FRUIT SALAD PASTRY DESSERT ICE CREAM

SEAFOOD SNAIL OYSTER OLIVE ASPARAGUS BEEF

CHEESE CRAB FONDUE SUCKET CARVING

KINDS OF SPOONS

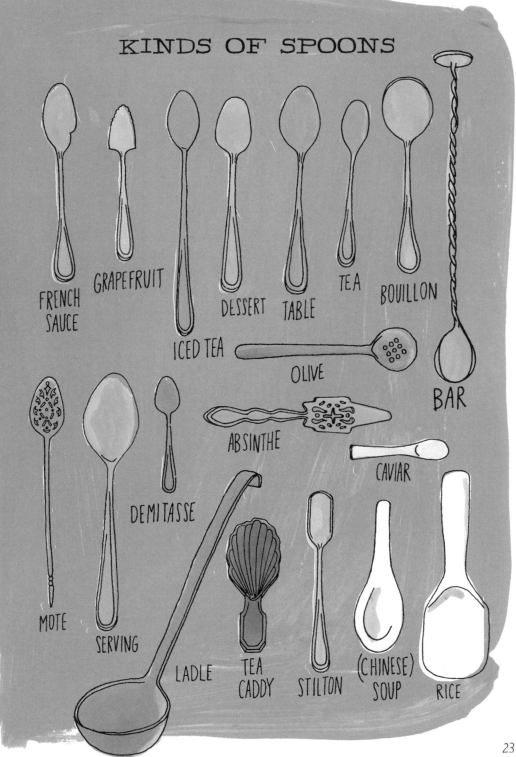

FRENCH SAUCE

GRAPEFRUIT

ICED TEA

DESSERT

TABLE

TEA

BOUILLON

OLIVE

BAR

MOTE

DEMITASSE

ABSINTHE

CAVIAR

SERVING

LADLE

TEA CADDY

STILTON

(CHINESE) SOUP

RICE

IN THE (INTERNATIONAL) CUPBOARD

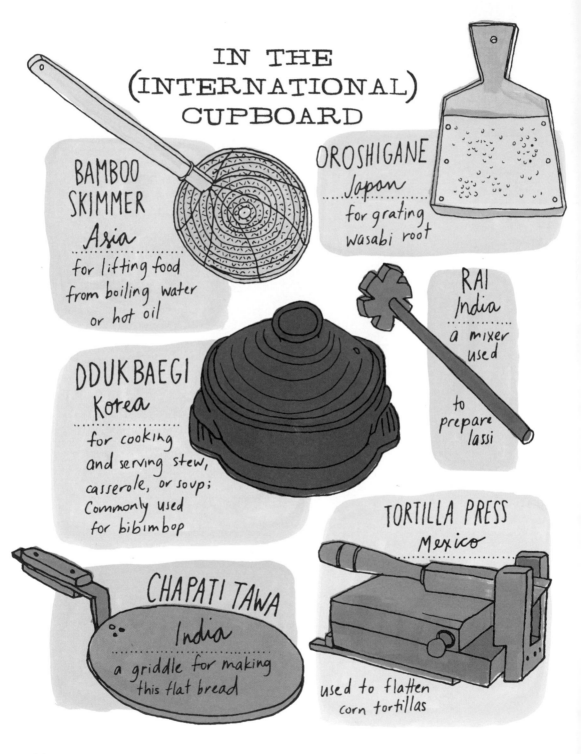

BAMBOO SKIMMER
Asia
for lifting food from boiling water or hot oil

OROSHIGANE
Japan
for grating wasabi root

RAI
India
a mixer used to prepare lassi

DDUKBAEGI
Korea
for cooking and serving stew, casserole, or soup; commonly used for bibimbop

CHAPATI TAWA
India
a griddle for making this flat bread

TORTILLA PRESS
Mexico
used to flatten corn tortillas

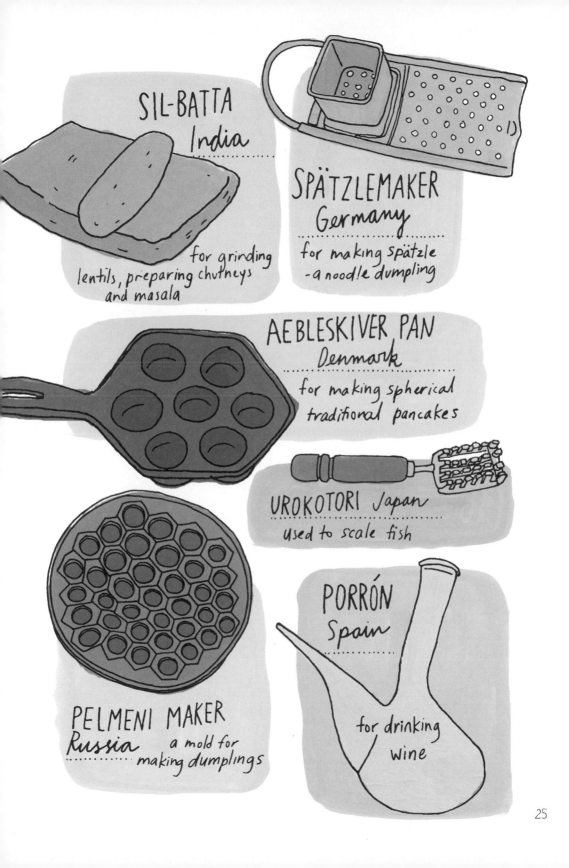

SIL-BATTA
India

for grinding lentils, preparing chutneys and masala

SPÄTZLEMAKER
Germany

for making spätzle
-a noodle dumpling

AEBLESKIVER PAN
Denmark

for making spherical traditional pancakes

UROKOTORI Japan

used to scale fish

PORRÓN
Spain

for drinking wine

PELMENI MAKER
Russia a mold for making dumplings

KARAHI India
for cooking stews

MOLINILLO Mexico
a whisk used to prepare hot beverages like hot chocolate

TAGINE POT North Africa
used to make tagines - savory stews

FONDUE POT Switzerland
for heating cheese and dipping in bread

KHANOM DOK BUA MOLD Laos
a lotus flower-shaped cookie mold

PAELLERA Spain
for making the national dish, paella, a rice dish with lots of meats and/or seafood.

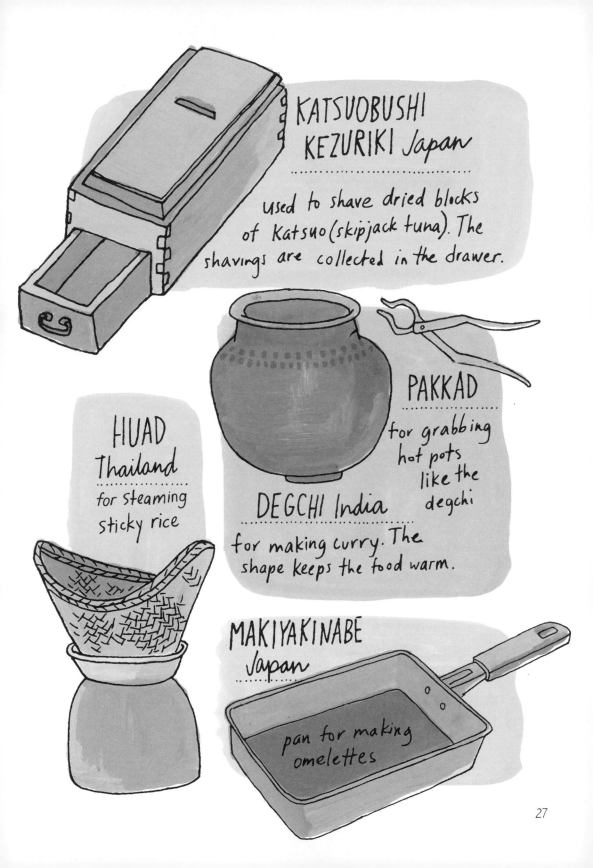

KATSUOBUSHI KEZURIKI *Japan*

used to shave dried blocks of katsuo (skipjack tuna). The shavings are collected in the drawer.

HUAD *Thailand*

for steaming sticky rice

PAKKAD

for grabbing hot pots like the degchi

DEGCHI *India*

for making curry. The shape keeps the food warm.

MAKIYAKINABE *Japan*

pan for making omelettes

TRADITIONAL OVENS
AROUND THE WORLD

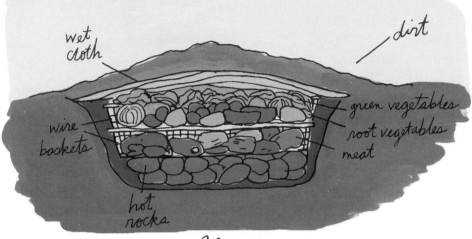

wet cloth

dirt

wire baskets

green vegetables

root vegetables

meat

hot rocks

Hāngi

A traditional Maori pit oven where meat and vegetables are cooked in baskets set atop heated stones and covered with a wet cloth and a thick layer of dirt.

Horno

This beehive-shaped outdoor adobe mud oven is still used by some Native Americans to cook bread and meat, and to steam corn.

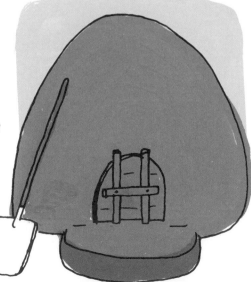

trays of fish

Chorkor

This rectangular wood-fueled oven from Ghana is used primarily to smoke fish, placed on screen frames that sit above the open flames.

Neapolitan

Built of stone and brick, these domed ovens are heated with wood or coal and date back to the Roman Republic or possibly earlier. They are still often used for making pizza.

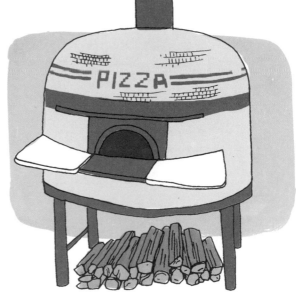

Tandoor

A Punjabi tandoor is a traditional Indian oven made of a bell-shaped clay cylinder that is sometimes buried partially underground. They are often used to bake flatbreads like naan and roti. The raw dough is stuck to the inside of the oven and peeled off when it's fully cooked.

A CENTURY OF STOVES

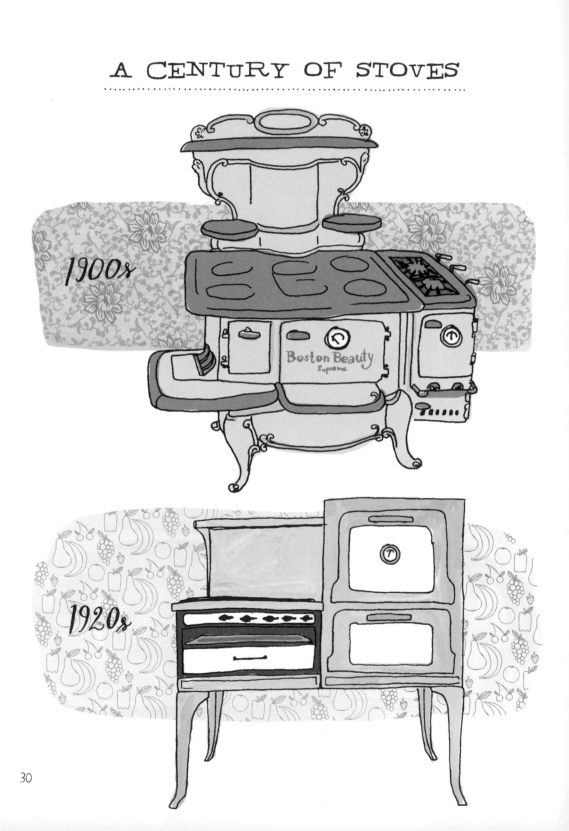

1900s

Boston Beauty
Supreme

1920s

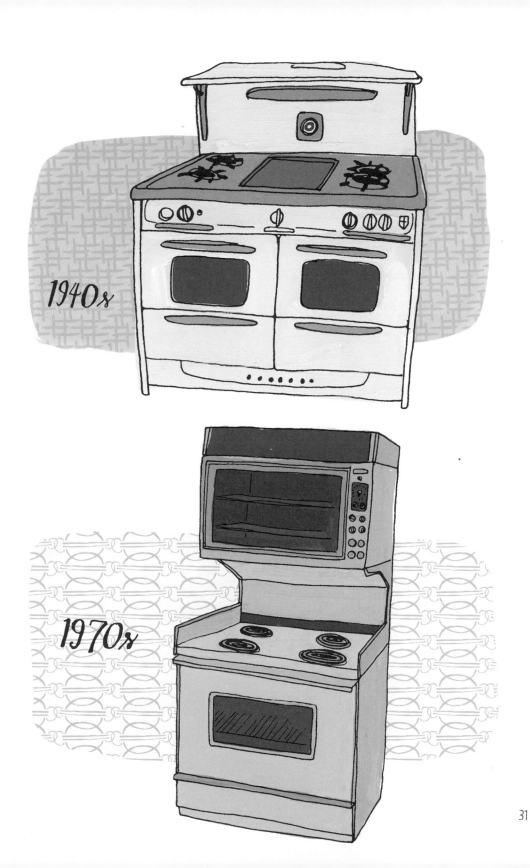

1940s

1970s

THE ICE AGE OF
REFRIGERATION

Modern refrigerators use chemicals and electricity to freeze or chill — but long before these were available, we used all kinds of other methods to keep our food cool.

ICE CUTTING

In the 19th century people used saws — either hand or horse-drawn — to cut and harvest ice from frozen lakes and ponds during winter. The blocks were lifted with tongs and delivered to ice houses and then to individual ice boxes.

ICE HOUSE

Built partially underground with insulated walls of straw and sawdust, these were used to store blocks of ice throughout the summer.

COOLGARDIE SAFE

Invented in the 1890s and named after a Gold Rush site, this cabinet had burlap walls. Water dripped from a reservoir, saturating the burlap and keeping the interior cool as it evaporated.

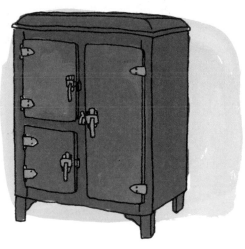

ICE BOX

Before home refrigerators arrived in the 1920s, an icebox kept things chilled. One chamber of this insulated cabinet held a block of ice, and the others stored food. As the ice melted, all the chambers were cooled.

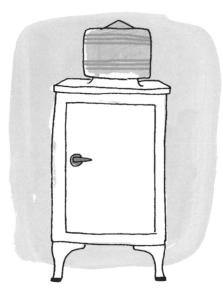

GE'S MONITOR-TOP

The first popular home refrigerator was the Monitor-Top by General Electric, which used toxic sulfur dioxide to keep food cold. When fridges with freon were introduced in the 1930s, the technology became safer and even more widespread.

FERMENTATION

Fermentation is the chemical breakdown and transformation of matter by bacteria and yeasts — it often results in effervescence, heat, and, if we're lucky, sensational food and drinks. It happens naturally but by controlling the process and the microorganisms at play, we can also influence flavor.

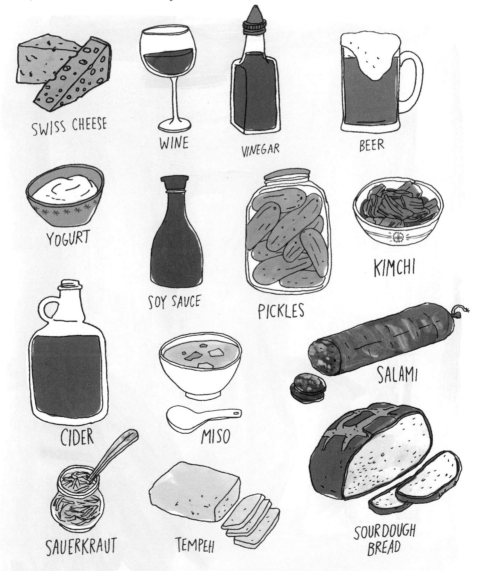

SWISS CHEESE

WINE

VINEGAR

BEER

YOGURT

SOY SAUCE

PICKLES

KIMCHI

CIDER

MISO

SALAMI

SAUERKRAUT

TEMPEH

SOURDOUGH BREAD

Humans have been producing fermented food and beverages since the Neolithic period. Evidence suggests early civilizations were making beer and wine 8,000 years ago; bread, possibly earlier.

Vessel for wine from 4200 BCE

Not only does fermentation alter the taste of the original ingredients, it preserves them — critically important in the centuries before canning and freezing. That's why some refer to fermentation as "controlled rot."

Before baker's yeast became available in the 20th century, cooks bought it from a brewer or captured their own wild yeasts in a sourdough starter. That's what makes sourdough bread so special, even today: Wild yeasts lend their own specific flavors in each location, unlike baker's yeast that always tastes the same.

Fermented foods are probiotic! We could not live without this good bacteria in our system.

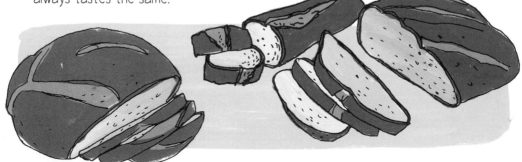

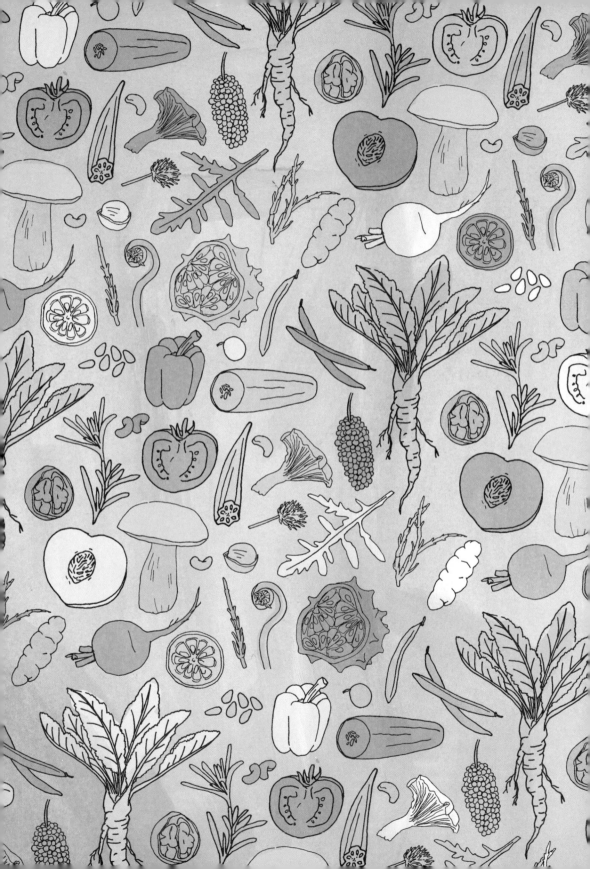

CHAPTER 2

Eat Your Fruits and Veggies

DINING ON THE PLANT FAMILY

There are four main groups of plants.

Mosses & Liverworts

Many of these are edible, though generally considered not very tasty.

SPANISH MOSS

REINDEER MOSS

OAK MOSS

Coniferous Trees

Delicious pine nuts and young needles are used like herbs to flavor things.

Ferns

Curly fiddleheads are a spring treat.

FIDDLEHEADS

LEMON TREE

Flowering Plants

Most of the fruits and vegetables we eat come from these.

EDIBLE PARTS OF FLOWERING PLANTS

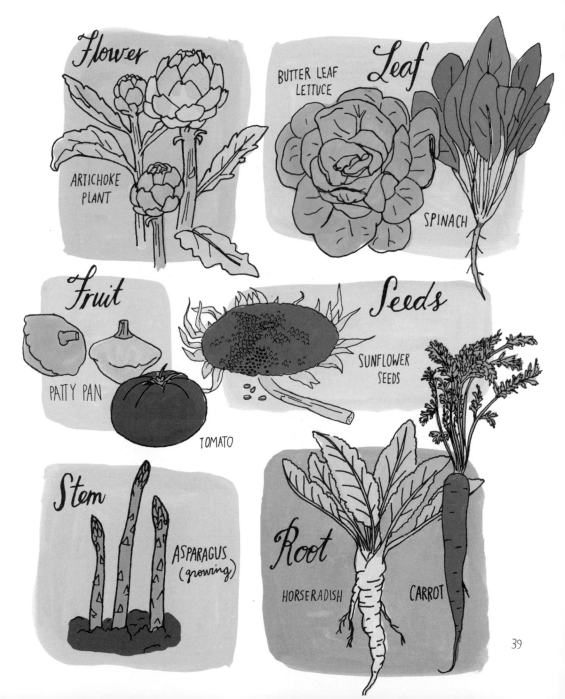

Flower

ARTICHOKE PLANT

Leaf

BUTTER LEAF LETTUCE

SPINACH

Fruit

PATTY PAN

TOMATO

Seeds

SUNFLOWER SEEDS

Stem

ASPARAGUS (growing)

Root

HORSERADISH

CARROT

FRUIT FACTS

Cooks divide the flowering plant world into fruits (which are sweet) and vegetables (almost everything else). But to botanists, what defines a fruit is function, not flavor: A fruit is the plant's ripe, seed-bearing ovary.

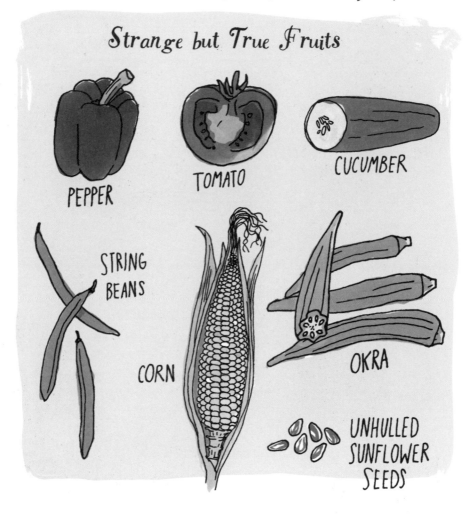

Strange but True Fruits

PEPPER

TOMATO

CUCUMBER

STRING BEANS

CORN

OKRA

UNHULLED SUNFLOWER SEEDS

To make it more confusing, since the Tariff Act of 1883, tomatoes, cucumbers, beans and peas have been legally classified as vegetables in the USA while a 1947 ruling made rhubarb a fruit.

How a Flower Becomes a Fruit

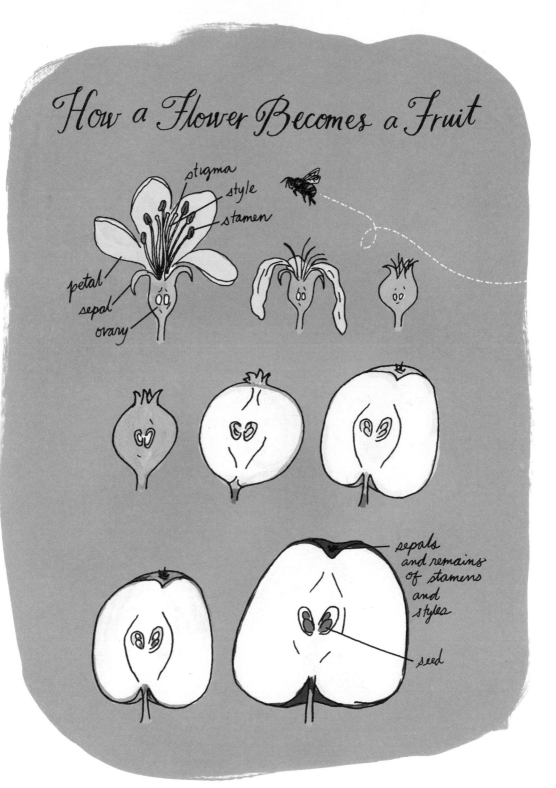

stigma
style
stamen
petal
sepal
ovary

sepals and remains of stamens and styles

seed

THE PARENTS OF PRODUCE

Since antiquity humans have practiced selective farming to manipulate certain qualities of the fruits and vegetables they grow, and in the modern agricultural era, technology and science supplement this process. We usually don't notice the difference on our plates year to year, but over centuries the produce we've come to think of as common has changed so much it barely resembles its ancestors.

Original Peach

Historians say the original peach tasted like a lentil, with a waxy skin and more pit than flesh. Chinese farmers turned it into the juicy, fuzzy, sweet fruit we crave today.

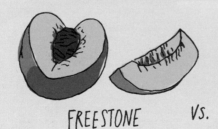

FREESTONE VS. CLINGSTONE

With a freestone peach, the flesh easily separates from the pit. The flesh of a clingstone sticks to the pit, making it harder to can and freeze.

Original Carrot

The original carrots from Persia were either purple or white and a few had branched roots.

DANVERS

NANTES

IMPERATOR

Original Corn

Ancient Mayans were able to take this small, dry, barely edible grain and turn it into a crop closely resembling the sweeter, easier-to-peel corn of today.

SHOE PEG

BLUE FLOUR

DENT

Original Watermelon

Originating from Botswana and Namibia, the watermelon used to be smaller and more bitter. The huge increase in size has made them easier to crack open. More recently, seedless varieties were developed.

DESERT KING

SUGAR BABY

JUBILEE

HOW TO CUT A MANGO

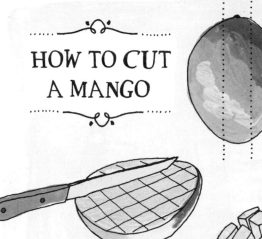

1. Cut off the two sides as close to the pit as possible.

2. Slice into the flesh side in both directions, making a criss-cross without breaking the skin.

3. Flip the sides inside out and cut away the cubes. Cut off any remaining flesh from the pit.

HOW TO CUT AN AVOCADO

1. Cut into and around the pit to split the avocado in half vertically.

2. Cut carefully into the pit with the middle of a strong knife, then twist and lift to remove the pit.

3. Using a spoon, scoop out the flesh in one piece, onto a plate. This should be easy if the avocado is ripe. Slice the avocado.

45

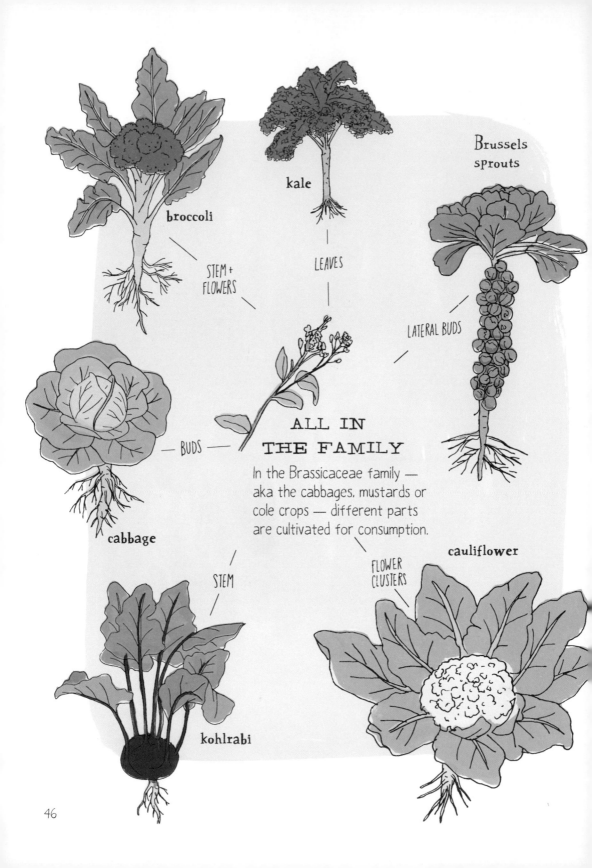

broccoli

kale

Brussels
sprouts

STEM +
FLOWERS

LEAVES

LATERAL BUDS

— BUDS —

ALL IN
THE FAMILY

In the Brassicaceae family —
aka the cabbages, mustards or
cole crops — different parts
are cultivated for consumption.

cabbage

cauliflower

STEM

FLOWER
CLUSTERS

kohlrabi

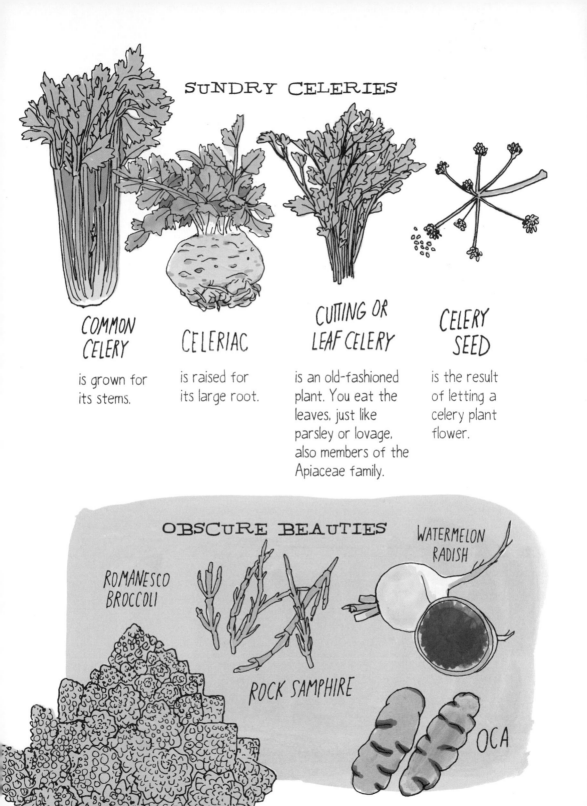

SUNDRY CELERIES

COMMON CELERY
is grown for its stems.

CELERIAC
is raised for its large root.

CUTTING OR LEAF CELERY
is an old-fashioned plant. You eat the leaves, just like parsley or lovage, also members of the Apiaceae family.

CELERY SEED
is the result of letting a celery plant flower.

OBSCURE BEAUTIES

ROMANESCO BROCCOLI

ROCK SAMPHIRE

WATERMELON RADISH

OCA

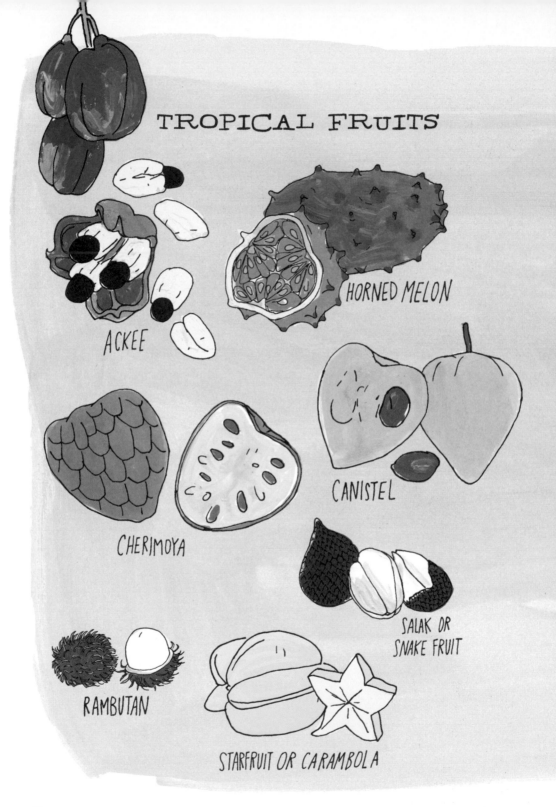

TROPICAL FRUITS

ACKEE

HORNED MELON

CHERIMOYA

CANISTEL

SALAK OR SNAKE FRUIT

RAMBUTAN

STARFRUIT OR CARAMBOLA

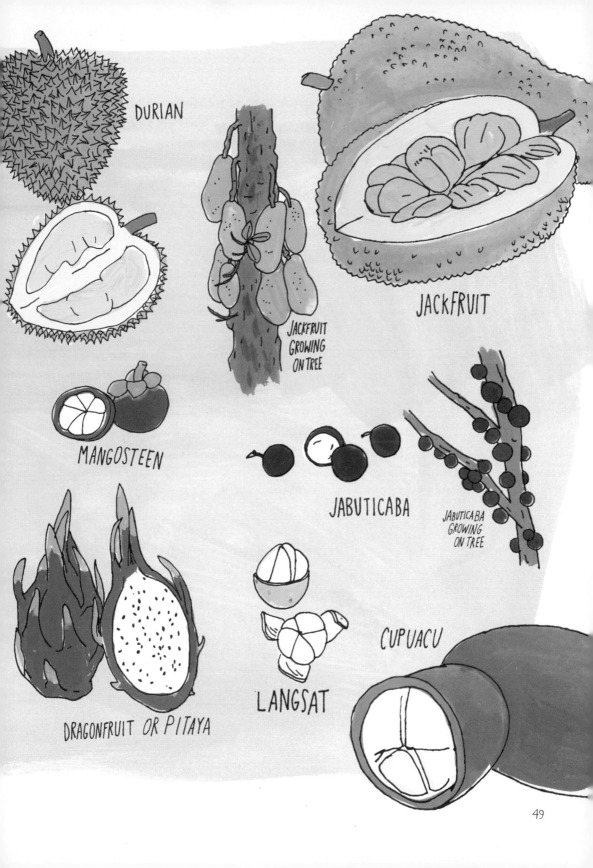

DURIAN

JACKFRUIT

JACKFRUIT GROWING ON TREE

MANGOSTEEN

JABUTICABA

JABUTICABA GROWING ON TREE

DRAGONFRUIT OR PITAYA

LANGSAT

CUPUACU

BERRY BASICS

Botanically speaking, all berries are fruits, but not all berries are berries.

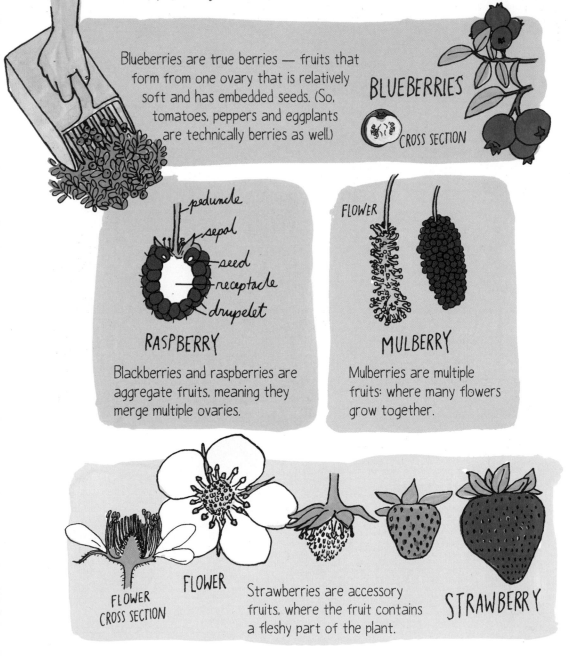

Blueberries are true berries — fruits that form from one ovary that is relatively soft and has embedded seeds. (So, tomatoes, peppers and eggplants are technically berries as well.)

BLUEBERRIES

CROSS SECTION

peduncle
sepal
seed
receptacle
drupelet

RASPBERRY

Blackberries and raspberries are aggregate fruits, meaning they merge multiple ovaries.

FLOWER

MULBERRY

Mulberries are multiple fruits: where many flowers grow together.

FLOWER CROSS SECTION

FLOWER

Strawberries are accessory fruits, where the fruit contains a fleshy part of the plant.

STRAWBERRY

Know Your Berries

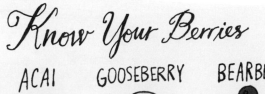

SALMONBERRY

LOGAN BERRY

ACAI

COWBERRY

GOOSEBERRY

ELDERBERRY

GOJI BERRY

BEARBERRY

CURRANT

CHOKECHERRY

LITTLE KNOWN TERMS
FOR COMMON TREE FRUIT

Drupe

Drupes — coconuts, olives, peaches, plums, and cherries — are fruits whose single seed is surrounded by a hard, stony layer. That's why many are known as "stone fruits."

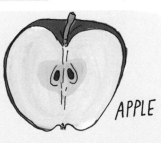

CHERRY
CROSS SECTION

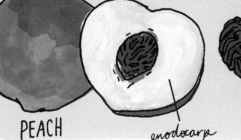

PEACH

seed

endocarp

Pome

Pomes — apples and pears — have a woody core that separates the seeds from the fruit.

APPLE

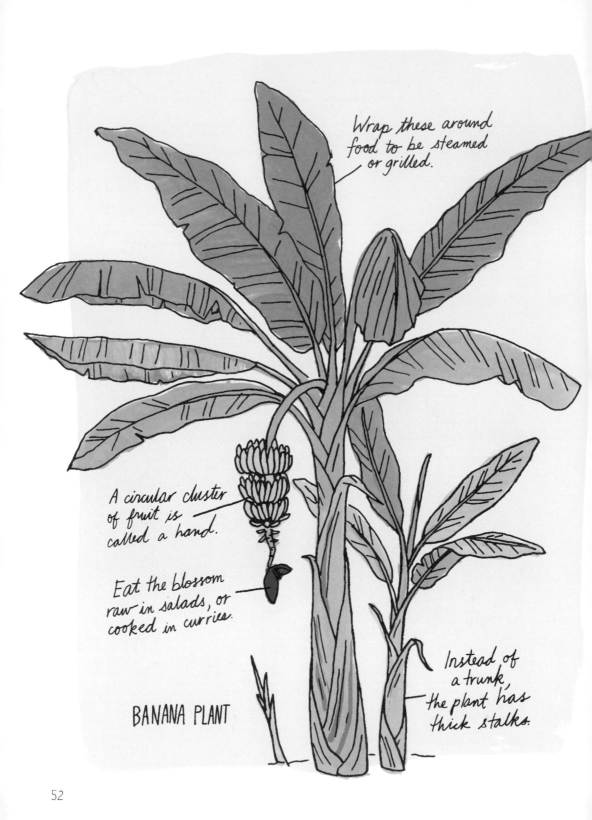

Wrap these around food to be steamed or grilled.

A circular cluster of fruit is called a hand.

Eat the blossom raw in salads, or cooked in curries.

BANANA PLANT

Instead of a trunk, the plant has thick stalks.

GO BANANAS

Americans typically eat only one type of *musa* — the botanical genus of which the banana is a member — but the fruit comes in many forms. There are stubby cultivars that have a tart-apple flavor and red-skinned bananas with pale pink flesh. Not to mention starchy plantains that are fried, still unripe, into chips call *tostones*.

WILD

Wild bananas are starchy and full of giant seeds.

PLANTAIN

Less sweet and more starchy than a banana

APPLE BANANA OR LATUNDAN

RED BANANA

SOME INTERESTING DISHES

PULUT INTI

a dessert of glutinous rice wrapped in banana leaf, topped with sweet coconut (Malaysia)

ARATIKAYA VEPUDU

raw plantain cut into cubes and fried with spices (South India)

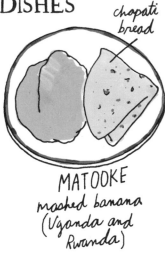

chapati bread

MATOOKE

mashed banana (Uganda and Rwanda)

CITRUS

Non Hybrids

Botanists believe that all types of citrus descend from these four ancient wild plants.

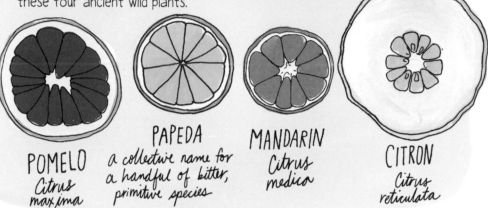

POMELO
Citrus maxima

PAPEDA
a collective name for a handful of bitter, primitive species

MANDARIN
Citrus medica

CITRON
Citrus reticulata

Extraordinary Hybrids

Most citrus fruit we eat today comes from natural or human hybridization, or the process of breeding two different plants together. Botanists often use an "x" in the scientific name of a hybridized plant, to illustrate the "cross" of two different fruits.

SHIKUWASA OR HIRAMI LEMON
Citrus x depressa

YUZU
Citrus ichangensis x reticulata

MAKRUT LIME
Citrus × hystrix

CALAMONDIN
× Citrofortunella mitis

BUDDHA'S HAND
Citrus medica var. sarcodactylus

used as a religious offering in Buddhist temples

UGLI
Citrus reticulata × Citrus paradisi

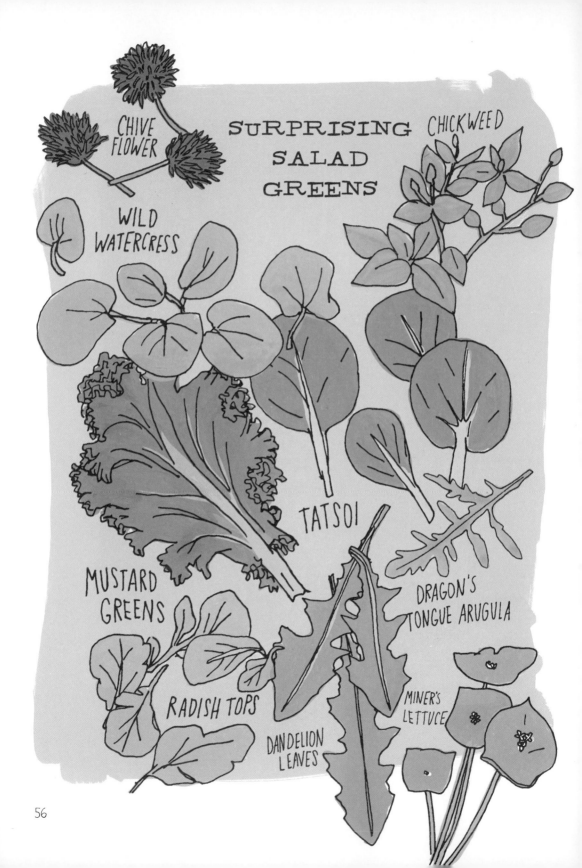

CHIVE FLOWER

SURPRISING SALAD GREENS

CHICKWEED

WILD WATERCRESS

TATSOI

MUSTARD GREENS

DRAGON'S TONGUE ARUGULA

RADISH TOPS

MINER'S LETTUCE

DANDELION LEAVES

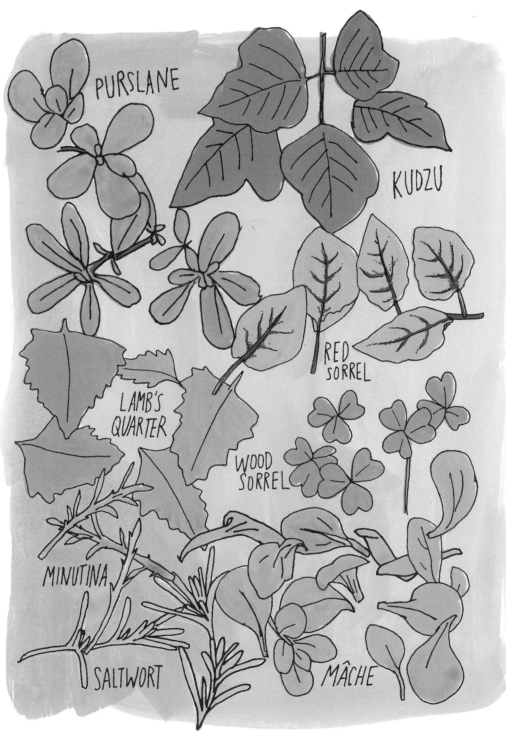

PURSLANE

KUDZU

RED SORREL

LAMB'S QUARTER

WOOD SORREL

MINUTINA

SALTWORT

MÂCHE

FAMOUS FUNGI

Aspergillus is a type of mold used to make soy sauce and sake.
A form of *Penicillium* mold makes blue cheese.

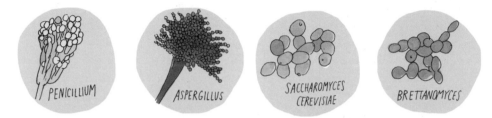

PENICILLIUM

ASPERGILLUS

SACCHAROMYCES CEREVISIAE

BRETTANOMYCES

Saccharomyces cerevisiae is the yeast used in baking, brewing, and winemaking, while *Brettanomyces* is what makes sour beers sour.

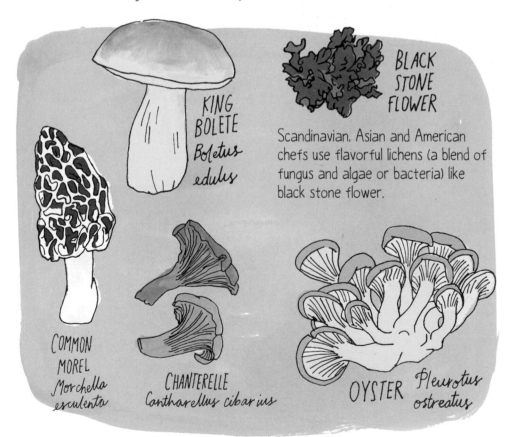

KING BOLETE
Boletus edulis

BLACK STONE FLOWER

Scandinavian, Asian and American chefs use flavorful lichens (a blend of fungus and algae or bacteria) like black stone flower.

COMMON MOREL
Morchella esculenta

CHANTERELLE
Cantharellus cibarius

OYSTER
Pleurotus ostreatus

The Truffle Hunter

The fanciest fungus by far is the subterranean truffle, technically the fruiting body of fungi that grow on tree roots. Though different species grow or can be cultivated in a surprising number of countries, those found growing naturally in Europe command the highest prices, up to $10,000 per pound.

Dogs are often used for truffle hunting instead of pigs because they can more easily be trained not to eat what they find.

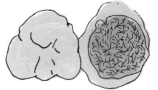

WHITE TRUFFLE
Tuber magnatum

The Mercedes of truffles are white varieties found in the Italian Piedmont in fall. Close runners-up are black winter truffles from southern France.

BLACK TRUFFLE
Tuber melanosporum

VANGHETTO — This Italian truffle hunter's tool has a short blade for digging up fungi from the forest floor.

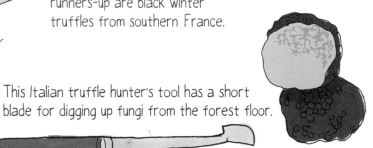

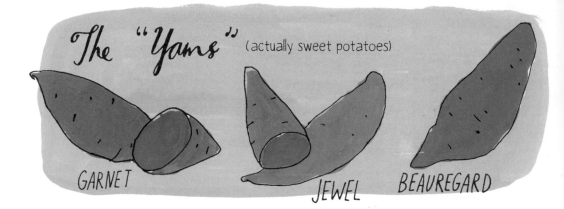

The "Yams" (actually sweet potatoes)

GARNET JEWEL BEAUREGARD

YAM VS. SWEET POTATO

Sweet potatoes — native to Central America — are sometimes called yams, but they are totally different plants. Starchy and dry, real yams are native to Africa and Asia, and can grow up to five feet long.

White Yam
DIOSCOREA ROTUNDATA Africa

Boiled and mashed or dried and smashed into a powder

Water Yam
DIOSCOREA ALATA
Philippines

aka the purple yam; used in desserts

Chinese Yam
DIOSCOREA OPPOSITA
Japan, China, Korea

Shredded or grated and used raw or lightly cooked in Japanese recipes. Also used in Chinese herbal medicine.

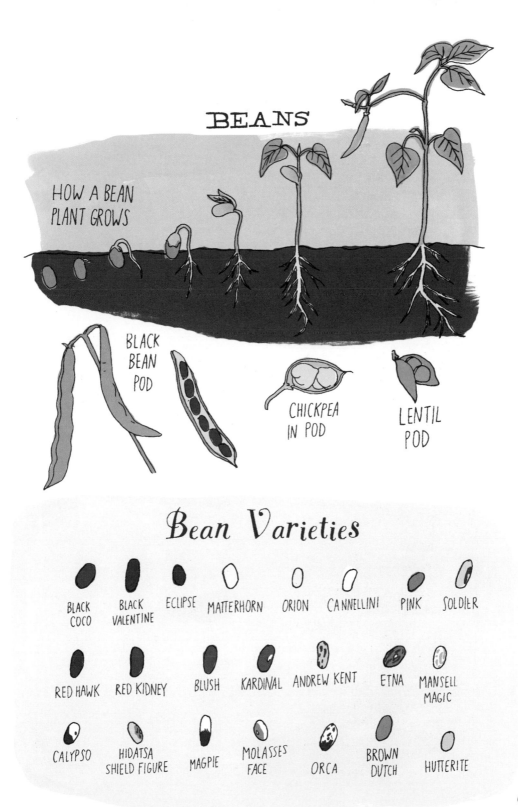

BEANS

HOW A BEAN PLANT GROWS

BLACK BEAN POD

CHICKPEA IN POD

LENTIL POD

Bean Varieties

BLACK COCO

BLACK VALENTINE

ECLIPSE

MATTERHORN

ORION

CANNELLINI

PINK

SOLDIER

RED HAWK

RED KIDNEY

BLUSH

KARDINAL

ANDREW KENT

ETNA

MANSELL MAGIC

CALYPSO

HIDATSA SHIELD FIGURE

MAGPIE

MOLASSES FACE

ORCA

BROWN DUTCH

HUTTERITE

SHELL GAMES

Only a handful of what we call nuts are true botanical nuts. While the word now applies to almost anything with a hard outer layer around edible seeds, true nuts such as acorns, beechnuts, chestnuts, and hazelnuts are always indehiscent — meaning their shells are all in one piece and don't naturally pop open.

the furry ripe chestnut burr

nuts

Chestnut

papery cupule

shell

Hazelnut

nuts

DIY NUT MILK:

Soak 1 cup nuts in 4 cups water overnight, then purée, strain, and sweeten to taste.

BETTER BUTTERS:

Purée any roasted nut, adding a little oil, salt, or sugar to taste.

FEELING NUTTY

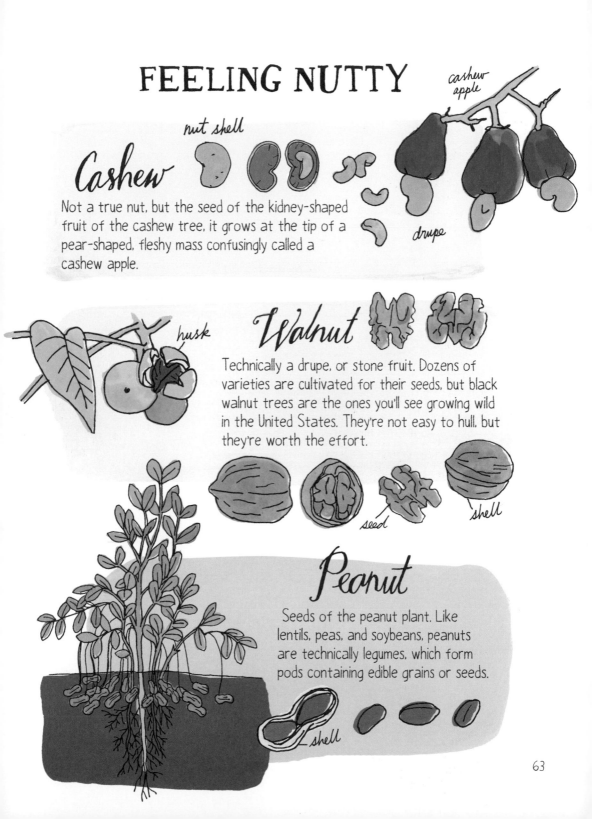

cashew apple

nut shell

Cashew

Not a true nut, but the seed of the kidney-shaped fruit of the cashew tree, it grows at the tip of a pear-shaped, fleshy mass confusingly called a cashew apple.

drupe

Walnut

husk

Technically a drupe, or stone fruit. Dozens of varieties are cultivated for their seeds, but black walnut trees are the ones you'll see growing wild in the United States. They're not easy to hull, but they're worth the effort.

seed

shell

Peanut

Seeds of the peanut plant. Like lentils, peas, and soybeans, peanuts are technically legumes, which form pods containing edible grains or seeds.

shell

PEANUT POWERED

Bumbu Kacang

Indonesian peanut sauce made with ground, cooked nuts, spices, and usually coconut milk, soy sauce, tamarind, galangal, and garlic. Typically served with gado gado, a cooked vegetable salad, and all manner of satay, or skewered, grilled meats.

Kong Bao Ji Ding

A Chinese dish, the precursor of American Kung Pao, made with dried chiles, peanuts, and chicken.

Ka'i Ladrillo

A popular peanut brittle from Paraguay — thought to be the peanut's ancestral home — made with molasses.

Maafe

A West African dish made by simmering meat in a salty-sweet sauce of ground peanuts or peanut butter, plus tomatoes, ginger, onion, and garlic. (It's also made with the West African groundnut, a similar legume.)

Kare Kare

A Filipino stew made with meat, eggplants, beans, greens, and crushed nuts or peanut butter.

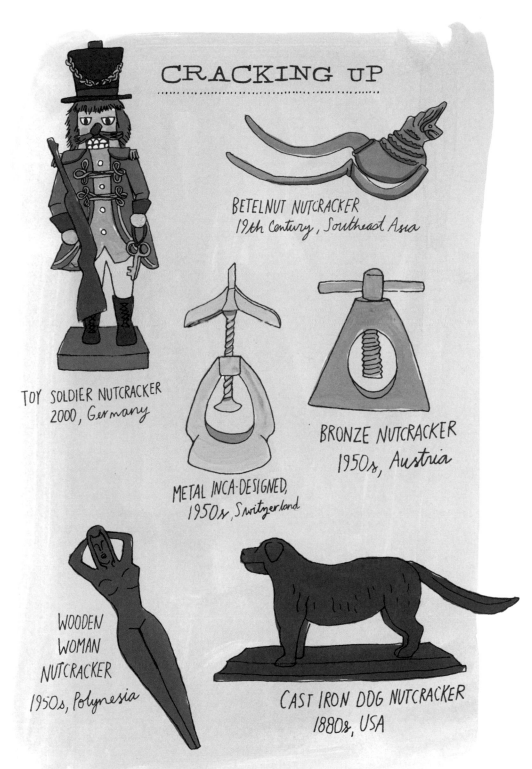

CRACKING UP

TOY SOLDIER NUTCRACKER
2000, Germany

BETELNUT NUTCRACKER
19th Century, Southeast Asia

METAL INCA-DESIGNED,
1950s, Switzerland

BRONZE NUTCRACKER
1950s, Austria

WOODEN
WOMAN
NUTCRACKER
1950s, Polynesia

CAST IRON DOG NUTCRACKER
1880s, USA

HOW TO MAKE TOFU

1. Make Soy Milk

Dried beans are soaked, mashed, cooked, and strained to make soy milk. The Japanese call the leftover pulp "okara" and add it to dishes like unohara, made with vegetables, soy sauce, and mirin.

2. Coagulate

Fresh soy milk is warmed then coagulated with "nigari," or what remains after salt is extracted from seawater. The skin that forms on the hot milk is called "yuba" — it's skimmed off and eaten too.

TOFU SKIN or YUBA

3. Curds & Whey

As in cheesemaking, tofu producers call the coagulated mixture of oil and soy protein "curds," and the leftover water that is strained off "whey."

4. The Press

Tofu curds can be eaten soft — it's even served with sweet syrup like custard — or pressed into harder bricks. The longer you press, the firmer it gets.

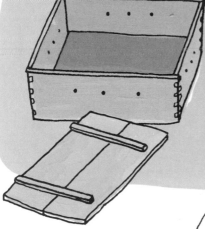

DOÙ GAN or DRY TOFU
an extra firm tofu where most of the moisture has been pressed out

SILKEN TOFU
creamy tofu that hasn't been pressed

CHAPTER 3

A Grain of Truth

Good Grains

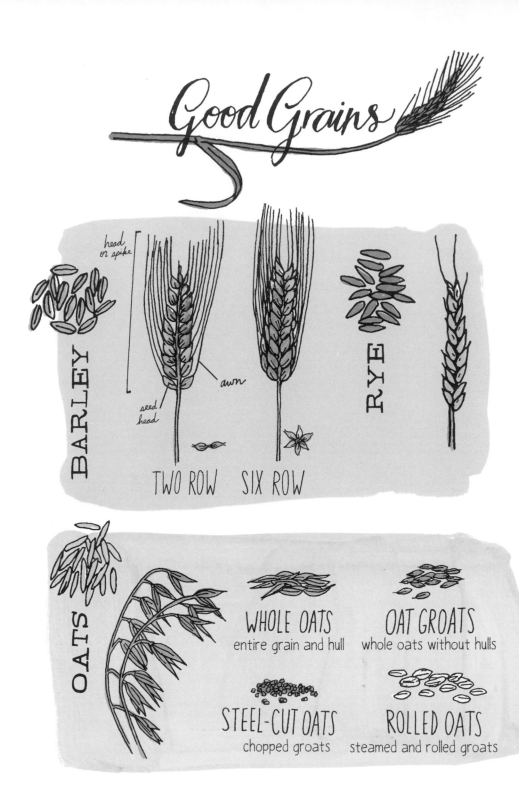

head
or spike

BARLEY

seed
head

awn

TWO ROW SIX ROW

RYE

OATS

WHOLE OATS
entire grain and hull

OAT GROATS
whole oats without hulls

STEEL-CUT OATS
chopped groats

ROLLED OATS
steamed and rolled groats

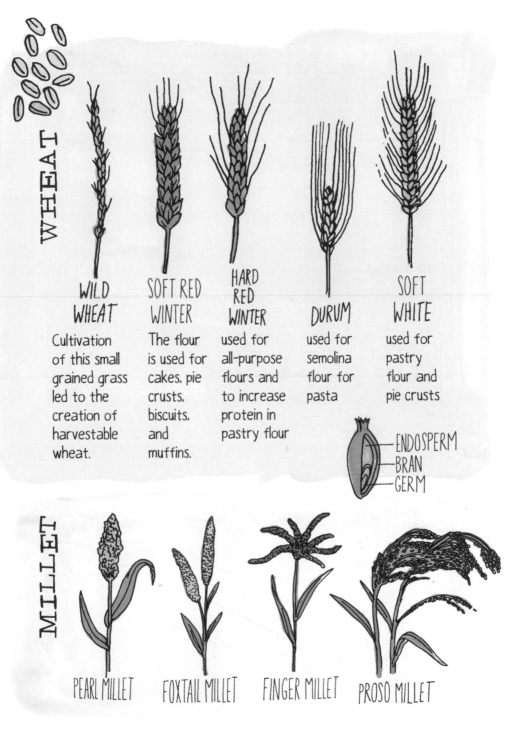

WHEAT

WILD WHEAT
Cultivation of this small grained grass led to the creation of harvestable wheat.

SOFT RED WINTER
The flour is used for cakes, pie crusts, biscuits, and muffins.

HARD RED WINTER
used for all-purpose flours and to increase protein in pastry flour

DURUM
used for semolina flour for pasta

SOFT WHITE
used for pastry flour and pie crusts

ENDOSPERM
BRAN
GERM

MILLET

PEARL MILLET FOXTAIL MILLET FINGER MILLET PROSO MILLET

QUINOA

BUCKWHEAT

SORGHAM

AMARANTH

TEFF

CORN

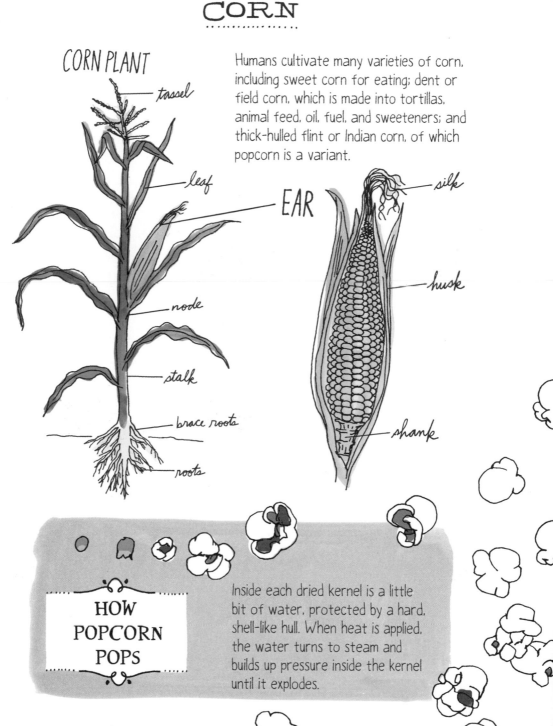

CORN PLANT

- tassel
- leaf
- node
- stalk
- brace roots
- roots

Humans cultivate many varieties of corn, including sweet corn for eating; dent or field corn, which is made into tortillas, animal feed, oil, fuel, and sweeteners; and thick-hulled flint or Indian corn, of which popcorn is a variant.

EAR

- silk
- husk
- shank

HOW POPCORN POPS

Inside each dried kernel is a little bit of water, protected by a hard, shell-like hull. When heat is applied, the water turns to steam and builds up pressure inside the kernel until it explodes.

KINDS OF RICE

ARBORIO

BASMATI

JASMINE

ROSE MATTA

BHUTANESE
RED

GLUTINOUS OR
STICKY

KOSHIHIKARI

CAMARGUE RED

BLACK

DARK WILD

BROWN SHORT GRAIN

RED CARGO

GROWING RICE

It usually takes three months to grow rice. One method is to hand-plant rows of seedlings in paddies that are flooded with water to prevent weeds. At three feet tall, the rice plants are cut with a knife and run through a thresher to separate the grains from the stalks. Grains are dried and then milled to remove the outer layers. With brown rice, only the husk is removed, leaving the nutty, nutrient-rich bran and germ. For white rice, all three outer layers are polished away.

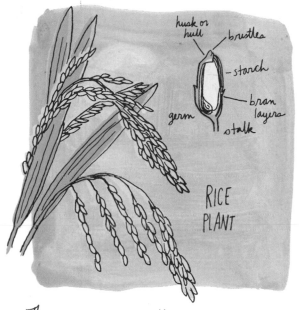

husk or hull
bristles
starch
germ
bran layers
stalk

RICE PLANT

There are more than 40,000 varieties of rice. It is grown on every continent except Antarctica.

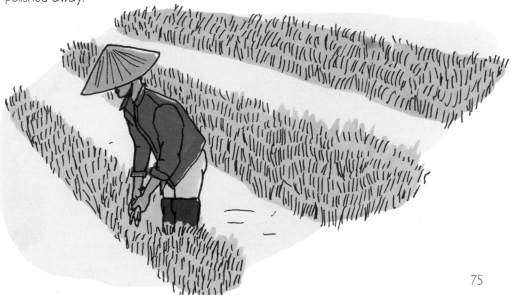

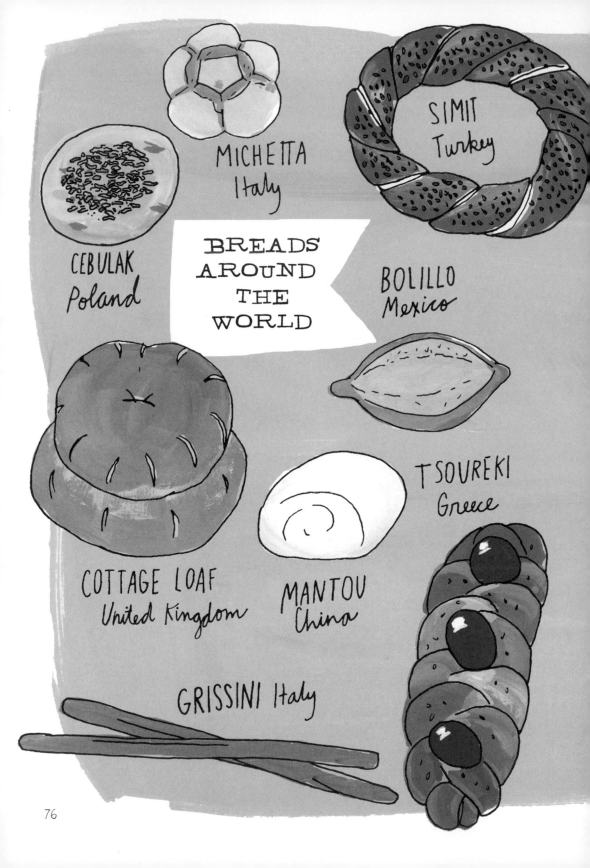

MICHETTA
Italy

SIMIT
Turkey

CEBULAK
Poland

BREADS
AROUND
THE
WORLD

BOLILLO
Mexico

TSOUREKI
Greece

COTTAGE LOAF
United Kingdom

MANTOU
China

GRISSINI Italy

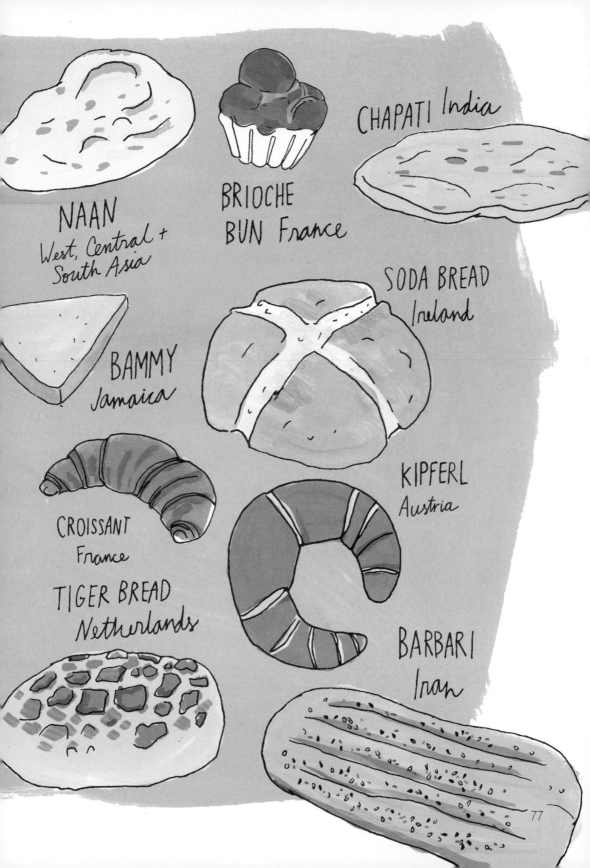

NAAN
West, Central +
South Asia

BRIOCHE
BUN France

CHAPATI India

BAMMY
Jamaica

SODA BREAD
Ireland

CROISSANT
France

KIPFERL
Austria

TIGER BREAD
Netherlands

BARBARI
Iran

ROLLING THE DOUGH

BOILING BAGELS

Before they're baked, these Eastern European bread rings are boiled to yield an appealingly chewy, hard crust.

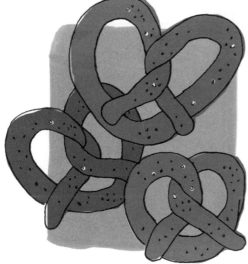

A TWISTED TALE

One of the many origin stories of pretzels dates back to 610 CE when Italian monks decided to bake some breads in the shape of a child crossing their arms in a pious fashion. They were given as a treat to the children for memorizing their prayers and were called "pretiolas" derived from the Latin "pretzola" meaning "little rewards."

KARELIAN PIE

These small rye bread pockets from the ancient region of Karelia — which includes parts of Finland, Russia, and Sweden — hold rice porridge and are often topped with a mixture of butter and eggs.

SWEDISH CINNAMON STAR BREAD

Often eaten during holidays, this cinnamon layered bread is formed in the shape of a star for a beautiful celebratory impression. The layered dough is cut into sections, keeping the center intact. Then each piece is twisted. During baking, the layers expand to make the star shape.

How to Braid a Challah

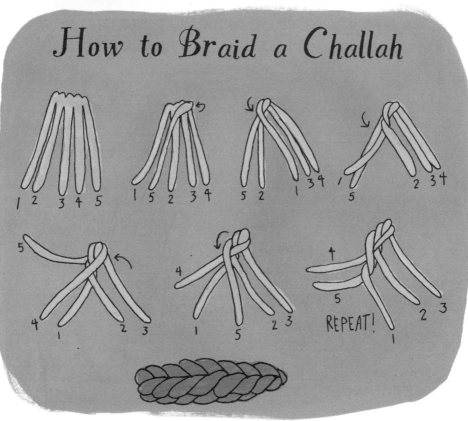

Baking Traditional Finnish Rye Bread With My Friend Pirjo Mustonen

Rye bread is a staple of every Finnish meal, usually served with cheese. It is dark, sour, and drier than many other European and American rye breads. My friend Pirjo has been making it her whole life, from a hundred-year-old sourdough starter — which she calls a "root" — that has been passed down by her family. Here's her three-day baking process.

DAY 1

The root is removed from the freezer where it is stored. It is about 3/4 cup of the dough from the last bake.

DAY 2 MAKING THE DOUGH

ROOT
12½ CUPS OF LUKEWARM WATER
½ to 1 TEASPOON OF YEAST
1½ POUNDS OF MEDIUM-ROUGH RYE FLOUR

Put the root of the bread into a large bowl or bucket. Mix the root, water and yeast. Add flour, stirring every few hours. Cover the bowl with a cloth.

MIXING TOOL
Made from carving the top of a spruce tree

80

DAY 3

1 TABLESPOON OF SALT
2½-3 POUNDS OF MEDIUM-ROUGH RYE FLOUR

Add salt into the dough. Mix the flour into the dough little by little. The dough should feel soft but also solid. Gather the dough into a mound and make a cross in it with a knife. This helps you determine how much it has risen. Cover the bowl with a cloth. Let it rise for 2-3 hours.

Dust the table with flour. Set the dough on the table and pull off about 3/4 cup of the dough. THIS WILL BE THE NEXT ROOT OF THE BREAD. Store the root in the freezer.

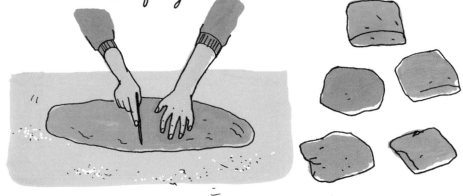

Divide the remaining dough into five even pieces.

Knead the pieces of dough by rolling them into long snake-like pieces and then curling those up into coils. Repeat that a few times.

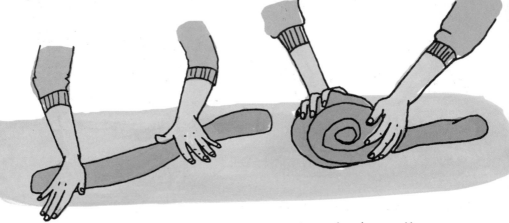

Gather the dough and use both hands to roll it back and forth on the table in a cone shape. Form the dough into a mound. Continue that process with the rest of the pieces.

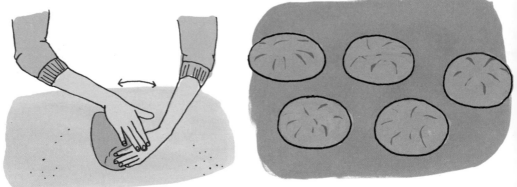

Cover and let them rise for 1½ hours. Preheat the oven to 450°F.

Prick each mound with a fork a few times.
Bake for about 1 hour. (Pirjo uses a wood-burning
oven.) Remove the breads and cover them as they cool.

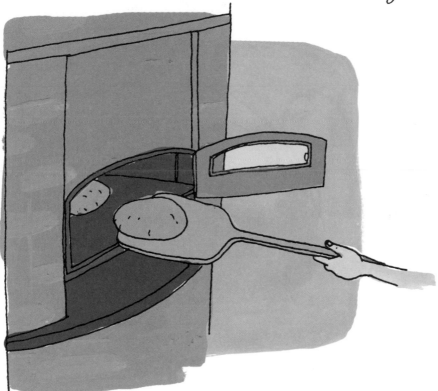

Enjoy with butter and cheese!

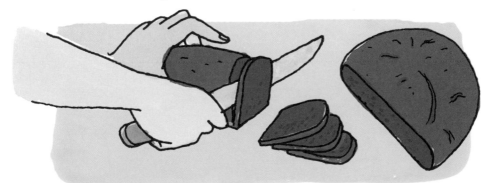

SUMPTUOUS SANDWICHES

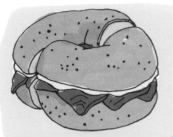

BAGEL LOX *New York, USA*
bagel, cured salmon, cream cheese,
sometimes onion and capers

BEEF AU JUS *France*
miniature French bread loaf,
roast beef, dip of meat drippings

BAURU *Bauru, Brazil*
French bun with crumb
removed, mozzarella,
roast beef, tomato and
pickled cucumber

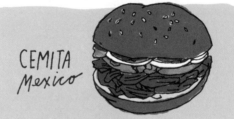

CEMITA
Mexico

brioche-like sesame seed roll, sliced
avocado, beef milanesa, panela (white
cheese), onion, papalo herb and red sauce

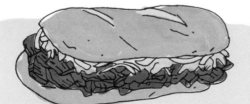

CHEESE STEAK *Philadelphia, USA*

long, soft roll, thin-sliced rib-eye or top
round beef, melted cheese, and sometimes
sauteed onion, peppers, and mushrooms

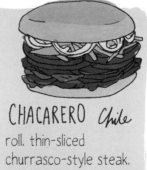

CHACARERO *Chile*
roll, thin-sliced
churrasco-style steak,
tomatoes, green beans,
chile pepper

CHORIPÁN
South America

crusty bread, chorizo, sauces like chimichurri (green sauce of parsley, garlic, oregano, oil and vinegar)

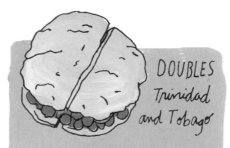

DOUBLES
Trinidad and Tobago

bara (flat fried bread), channa (curried chickpeas), mango, shadon beni herb, cucumber, coconut, tamarind, pepper sauce

FISCHBRÖTCHEN
Northern Germany

fish, onions, pickles, and a sauce such as remoulade, ketchup, or cocktail

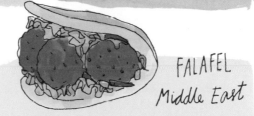

FALAFEL
Middle East

pita bread, falafel (deep-fried ball made of ground chickpeas or fava beans), lettuce, tomato, pickled vegetables, hot sauce, tahini sauce

GATSBY Cape Town, South Africa

long roll, french fries, meat (masala steak, chicken, sausage) or seafood (fish or calamari)

FRANCESINHA Porto, Portugal

bread, ham, linguiça, fresh sausage (chipolata), steak or roast meat, cheese, tomato and beer sauce

KATSU-SANDO
Japan
breaded, deep-fried pork cutlet, kewpie mayonnaise, Japanese mustard, tonkatsu sauce

LAMPREDOTTO
Florence, Italy
crusty bun, tripe from the fourth stomach of the cow, parsley green sauce, hot chile sauce

LOBSTER ROLL
New England, USA
hot dog bun, lobster, mayonnaise or butter

MONTE CRISTO
United States
bread dipped in egg batter, ham, cheese, powdered sugar, maple syrup or jam on the side

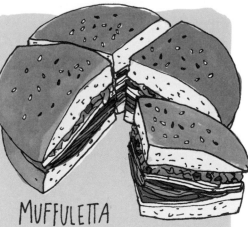

MUFFULETTA
Louisiana, USA
round loaf of sesame seed bread, olive salad, mozzarella, provolone, mortadella, salami, ham, giardiniera, or pickled vegetable relish

PAN BAGNAT
Nice, France
French sourdough, hard-boiled eggs, anchovies, tuna, raw vegetables, olive oil

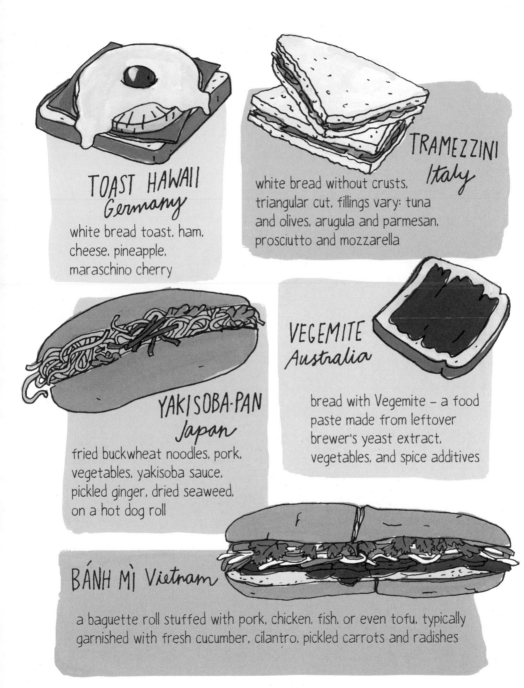

TOAST HAWAII
Germany

white bread toast, ham,
cheese, pineapple,
maraschino cherry

TRAMEZZINI
Italy

white bread without crusts,
triangular cut, fillings vary: tuna
and olives, arugula and parmesan,
prosciutto and mozzarella

YAKISOBA-PAN
Japan

fried buckwheat noodles, pork,
vegetables, yakisoba sauce,
pickled ginger, dried seaweed,
on a hot dog roll

VEGEMITE
Australia

bread with Vegemite – a food
paste made from leftover
brewer's yeast extract,
vegetables, and spice additives

BÁNH MÌ *Vietnam*

a baguette roll stuffed with pork, chicken, fish, or even tofu, typically
garnished with fresh cucumber, cilantro, pickled carrots and radishes

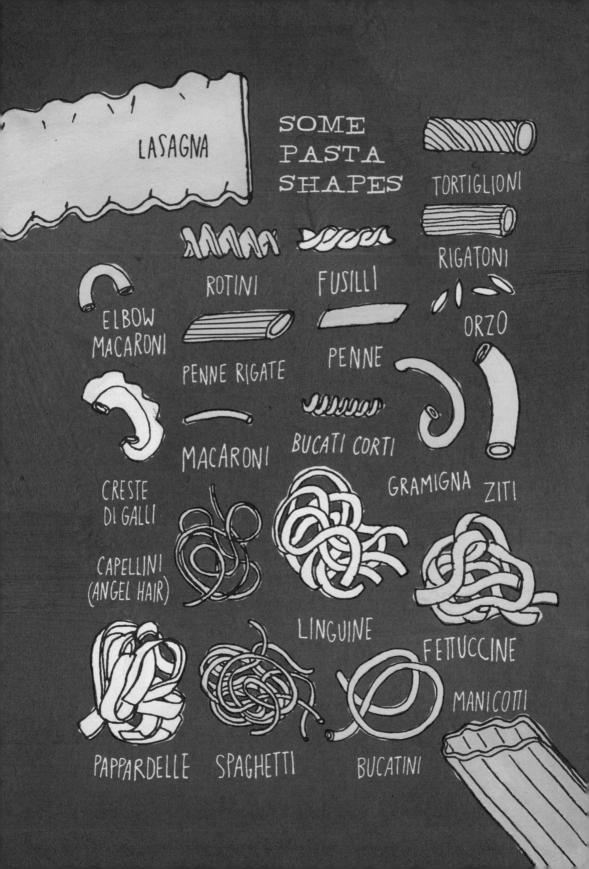

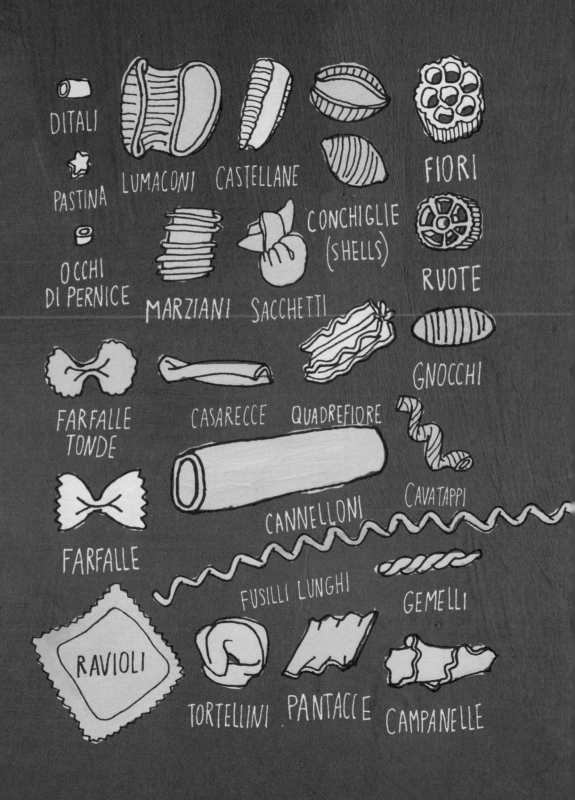

DITALI

PASTINA

OCCHI
DI PERNICE

LUMACONI

CASTELLANE

MARZIANI

SACCHETTI

CONCHIGLIE
(SHELLS)

FIORI

RUOTE

FARFALLE
TONDE

CASARECCE

QUADREFIORE

GNOCCHI

FARFALLE

CANNELLONI

CAVATAPPI

RAVIOLI

FUSILLI LUNGHI

TORTELLINI

PANTACCE

GEMELLI

CAMPANELLE

MAKING PASTA

Pasta dough can be made from combining just flour and eggs.

The dough is then put through a machine to make it into very thin sheets, or to cut it into long strands.

HOME PASTA ROLLER MACHINE

Those sheets could be used to make ravioli.

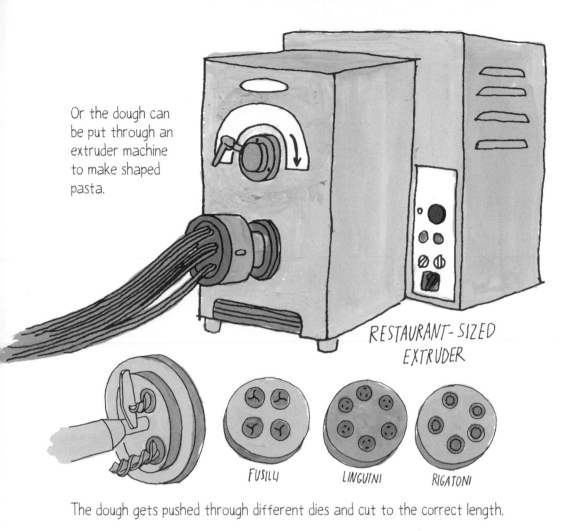

Or the dough can be put through an extruder machine to make shaped pasta.

RESTAURANT-SIZED EXTRUDER

FUSILLI LINGUINI RIGATONI

The dough gets pushed through different dies and cut to the correct length.

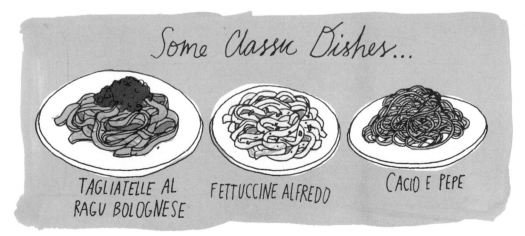

Some Classic Dishes...

TAGLIATELLE AL RAGU BOLOGNESE FETTUCCINE ALFREDO CACIO E PEPE

MAKING NOODLES

Making noodles by hand is a long-standing Asian tradition — the earliest text describing the process dates to 1504.

LAMIAN

Lamian are Chinese wheat flour noodles "pulled" from a single piece of high-gluten dough — hence the English translation to "pulled noodles." In one method, the gluten is developed by repeatedly stretching the dough and letting it snap against a counter, then twisting it over on itself.

To make the noodles, the finished dough is stretched wide, then folded over on itself, creating two thick strands. Those are stretched and then folded over, creating four thinner strands. And so on, until the desired thinness of noodle is achieved.

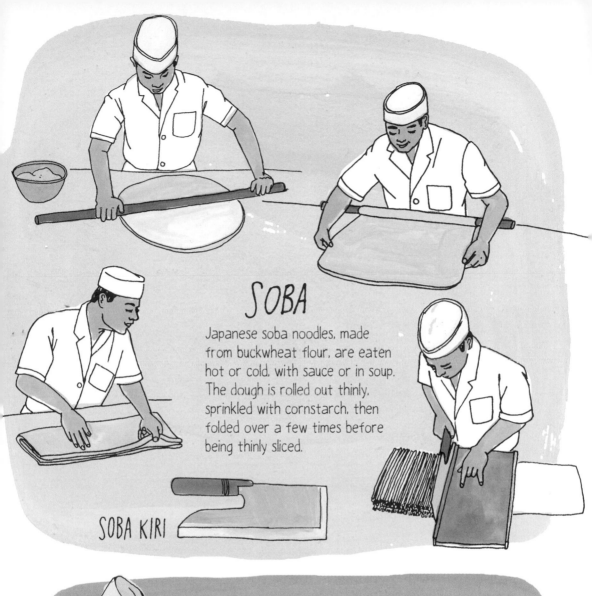

SOBA

Japanese soba noodles, made from buckwheat flour, are eaten hot or cold, with sauce or in soup. The dough is rolled out thinly, sprinkled with cornstarch, then folded over a few times before being thinly sliced.

SOBA KIRI

DAO XIAO MIAN

Dao Xiao Mian are knife-shaved noodles from the Chinese province of Shanxi. Cooks shave or peel a log of dough with a sharp blade, creating thick, chewy, deliciously irregular noodles that fall directly into a boiling pot of water to cook.

93

ASIAN NOODLE DISHES

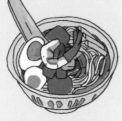

LAKSA, Singapore

rice noodles, and prawns or fish
in a spicy, coconut milk curry soup

DAN DAN NOODLES, China

noodles, pork and scallion
in a spicy Sichuan sauce

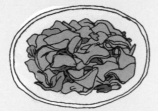

DRUNKEN NOODLES (PAD KEE MAO)
Thailand and Laos

broad rice noodles, soy sauce,
fish sauce, meat or seafood,
vegetables, and a chile, pepper,
and basil seasoning

MILMYEON, Korea

long thin noodles made of flour and
sweet potato starch in a meat
broth with vegetables and egg

KYAY OH, Myanmar
rice noodles, meat balls, pork broth

BÁNH HỎI, Vietnam
rice noodles woven into
clumps, scallions, meat

Jane's (My Mom) Noodle Pudding

10-12 OZ. BROAD EGG NOODLES
1 STICK SWEET BUTTER
1 LB. POT CHEESE OR FARMER CHEESE
16 OZ. SOUR CREAM

8-10 EGGS
3/4 CUP SUGAR
GROUND CINNAMON

(It is best if the refrigerated ingredients are at room temperature)

1. Boil the noodles until they are al dente, the shortest time on the instructions.

2. While the noodles boil, beat the eggs well with a whisk in a large bowl. Add in the pot cheese, sugar and sour cream. It should be well mixed and soupy. If it's not soupy, add an extra beaten egg or two.

3. Drain the noodles, tossing them gently until all the excess water is removed. Transfer them to a large bowl.

4. Take the stick of butter and swirl it around the hot drained noodles. This will melt the butter and evenly distribute it among the cooling noodles.

5. When the noodles have cooled off, fold the cheese, sour cream, sugar and egg mixture in with the noodles until it is all combined evenly.

6. Pour it all into a greased baking dish approximately 9×13".

7. Sprinkle the top with a dusting of cinnamon. Bake at 350° for approximately 1 hour or until the top is browned and the egg custard has set.

8. Let stand. Cut into square portions. Serve hot or cold.

DELECTABLE DUMPLINGS FROM AROUND THE WORLD

KHINKALI

Georgians fill these with minced meat and dust them with black pepper. Traditionally, the knot of dough on top — known as the kuchi, or belly button — isn't eaten.

CANEDERLI

Bread dumplings from the Alps of northeast Italy, often flavored with smoked, cured meat called speck. The many native German-speakers in this region call them Knödel.

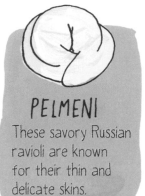

PELMENI

These savory Russian ravioli are known for their thin and delicate skins.

SIN MANTI

Armenia's open-faced, baked lamb dumplings are often eaten with yogurt.

MODAK

An Indian sweet that comes in many flavors, it is thought to be a favorite of the Hindu god Ganesh.

MODAK IN MOLD

Fufu is often used in lieu of utensils to carry food to the mouth

FUFU

These African or West Indian dumplings made from cassava, semolina, or corn flour are usually eaten with soup or stew.

MOMO

This famous South Asian dish is made in many shapes and with myriad fillings, including yak.

HALUŠKY

Topped with cheese and bacon, Slovakia's rustic potato gnocchi are considered the national dish.

XIAO LONG BAO

Also known as soup dumplings, these juicy Shanghainese pork dumplings are usually served straight from the xiaolong, or steamer that gives them their name.

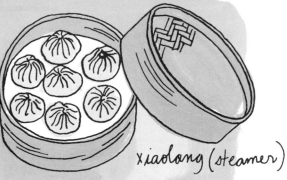

xiaolong (steamer)

PANCAKES AROUND THE WORLD

INJERA, Ethiopia

a spongy, fermented flatbread made from teff flour

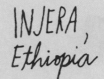

ÆBLESKIVER, Denmark

spherical pancakes made from flour, buttermilk, cream, eggs and sugar

HOTTEOK, Korea

a sweet pancake filled with brown sugar, honey, peanuts and cinnamon

SERABI, Indonesia

rice flour pancakes made with coconut milk, and pandan leaf juice, which turns them green

CHATAMARI, Nepal

a rice pancake snack with toppings of meat and vegetables and sometimes egg and cheese

BLINTZES, Russia

a very thin wheat flour pancake that is folded to hold cheese or fruit before getting sauteed

DOSA, India

made from fermented batter. this rice and urad bean pancake is served with a variety of chutneys

CREPE, France

a thin wheat or buckwheat flour pancake served folded up with either sweet or savory fillings

CHAPTER 4

*The Meat
of the
Matter*

PRIME CUTS

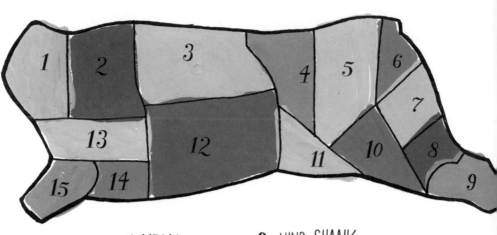

BEEF

1 NECK
2 CHUCK
3 RIB
4 SHORT LOIN
5 LOIN END
6 RUMP
7 ROUND
8 DIAMOND

9 HIND SHANK
10 SIRLOIN TIP
11 FLANK
12 SHORT PLATE
13 ENGLISH CUT
14 BRISKET
15 FORESHANK

When meat is sliced, it is always cut against the grain. This makes it more tender.

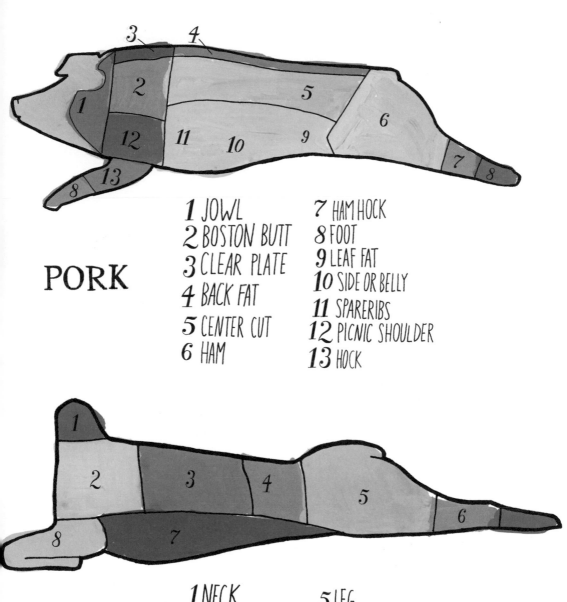

PORK

1 JOWL
2 BOSTON BUTT
3 CLEAR PLATE
4 BACK FAT
5 CENTER CUT
6 HAM
7 HAM HOCK
8 FOOT
9 LEAF FAT
10 SIDE OR BELLY
11 SPARERIBS
12 PICNIC SHOULDER
13 HOCK

LAMB

1 NECK
2 CHUCK
3 RACK OR RIB
4 LOIN
5 LEG
6 SHANK
7 BREAST
8 FORESHANK

HOW MEAT COOKS

Meat is mostly muscle, or little bundles of cells filled with fibers made up of proteins. Protein molecules are essentially tightly wound coils. Apply heat and the structure of those fibers change: The bonds that hold the coils break, and the molecules inside unwind. The fibers then shrink as water is squeezed out, and the unwound protein molecules coagulate, or join together into a semi-solid state. This process is called denaturing; it also explains why the texture of meat grows firmer as it cooks.

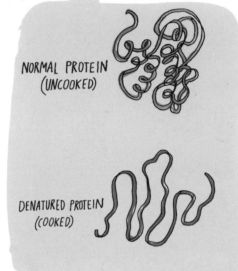

NORMAL PROTEIN (UNCOOKED)

DENATURED PROTEIN (COOKED)

Cooking Temperatures

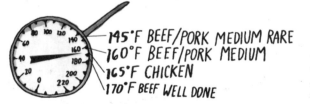

145°F BEEF/PORK MEDIUM RARE
160°F BEEF/PORK MEDIUM
165°F CHICKEN
170°F BEEF WELL DONE

WET HEAT

Boiling, steaming, and stewing are ideal for tough meats or those with lots of sinew or muscle.

Bollito misto is a prized Italian dish where many tougher cuts of meat and a stewing hen are simmered for hours in aromatic stock. They make a similar dish in France called pot-au-feu, or "pot on the fire."

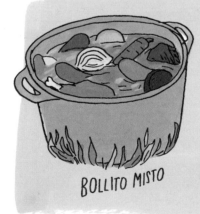

BOLLITO MISTO

DRY HEAT

These methods transfer heat directly to the meat by hot air, fire, or the cooking surface itself. Frying is considered "dry" because oil is used instead of water.

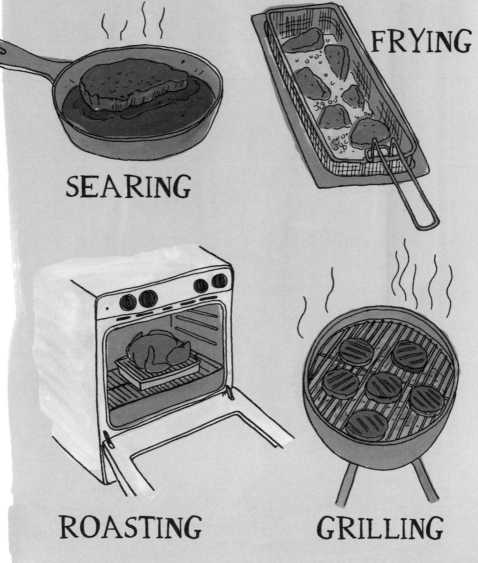

SEARING

FRYING

ROASTING

GRILLING

On the Charcuterie Plate

It may have started as a simple pre-refrigeration technique to preserve meat, but the art of charcuterie — from the old French words "char" (flesh) and "cuit" (cooked) — now produces some of world's most coveted flavors.

CURED HAM
aged pork leg that's first salted and/or smoked, sometimes with herbs and spices

PICKLES

OLIVES

PÂTES & TERRINES

Both are forcemeats, or ground or chopped lean meat mixed with fat, that are cooked in a mold and served cold; terrines tend to be chunkier.

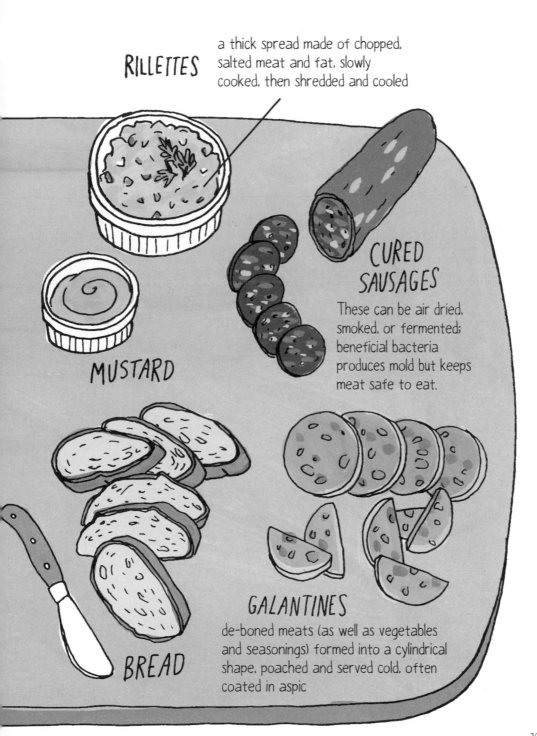

RILLETTES a thick spread made of chopped, salted meat and fat, slowly cooked, then shredded and cooled

MUSTARD

CURED SAUSAGES

These can be air dried, smoked, or fermented; beneficial bacteria produces mold but keeps meat safe to eat.

BREAD

GALANTINES

de-boned meats (as well as vegetables and seasonings) formed into a cylindrical shape, poached and served cold, often coated in aspic

SAUSAGE BLENDS

SUMMER SAUSAGE

beef, sugar, mustard seed, garlic powder,
cayenne, red pepper flakes, liquid smoke

BRATWURST

pork, veal, powdered
milk, pepper, sage,
onion, mace, and celery

MILD
ITALIAN

pork, fennel, black pepper

MORCILLA

pork blood, fat, rice, onions,
black pepper, paprika,
cinnamon, cloves, oregano

KIELBASA

pork, white pepper, coriander, garlic

MERGUEZ

lamb or beef, cumin,
chile pepper, harissa,
sumac, fennel, garlic

CHORIZO
MEXICANA

pork, chiles, coriander, cumin,
cloves, cinnamon, garlic,
paprika, salt, pepper, vinegar

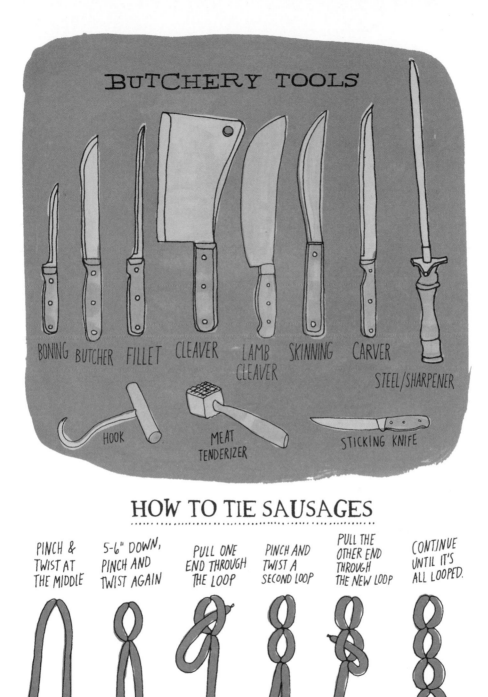

BUTCHERY TOOLS

BONING BUTCHER FILLET CLEAVER LAMB CLEAVER SKINNING CARVER

STEEL/SHARPENER

HOOK MEAT TENDERIZER STICKING KNIFE

HOW TO TIE SAUSAGES

PINCH & TWIST AT THE MIDDLE

5-6" DOWN, PINCH AND TWIST AGAIN

PULL ONE END THROUGH THE LOOP

PINCH AND TWIST A SECOND LOOP

PULL THE OTHER END THROUGH THE NEW LOOP

CONTINUE UNTIL IT'S ALL LOOPED.

MEATY DISHES
AROUND THE WORLD

BULGOGI, South Korea

thin slices of beef marinated in
soy sauce, sugar, sesame oil, garlic,
and other ingredients, including
mushrooms or pureed pears

MEAT PIE, Australia

diced or minced meat with gravy,
onions, and mushrooms in a double
crust, personal-sized pie shell,
often topped with ketchup

LECHÓN ASADO, Cuba

a whole pig or leg marinated in sour
orange juice, garlic, and oregano

PEKING DUCK, China

duck are specially bred, carefully
seasoned, boiled, dried, and roasted
to yield extra-crispy skin

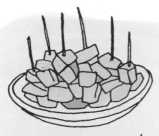

HÁKARL, Iceland

an extremely pungent ancient Icelandic dish — shark is buried, left to ferment, then hung for several months to dry

GOULASH, Hungary

a brick-red Hungarian beef and vegetable stew whose most important ingredient is the paprika

BIGOS, Poland

sauerkraut and meat stew, sometimes served in a hollowed loaf of bread

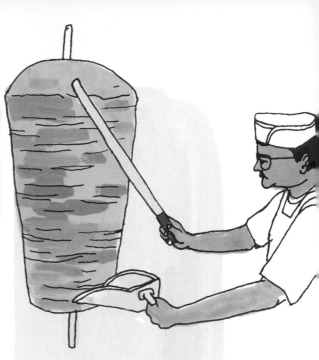

DÖNER KEBAB, Turkey

seasoned meat stacked and cooked on a vertical spit, then thinly shaved to order over rice or in a sandwich

KIBBEH, Middle East/ North Africa

patties of finely ground meat, spices, onions and bulgur, or cracked wheat — it can be fried, baked or served raw

FIVE FABULOUS FOOD FISH

rainbow trout

Unlike most species of fish commonly called trout — found in freshwater rivers and lakes — the Pacific Northwest species of these salmon relatives often spend a stint in the Pacific Ocean before returning to cold-water streams to spawn.

Most are cooked whole, pan-fried, stuffed and baked, or grilled.

Along Mexico's Pacific coast, high fat marlin meat is often smoked and served in tacos and tostadas

blue marlin

Some females of these pointy-billed fish grow to be more than 14 feet long, making them of the most coveted species for deep-water sport fishing. Though commercially fished in far smaller numbers, its numbers are decreasing, making it an endangered species.

winter flounder

Not to be confused with its similar-looking cousin, the summer flounder, this bottom-feeding Atlantic Ocean dweller is the flatfish most often praised for its delicious white meat.

As flounder grow, one eye slowly migrates around the body so that both end up on the same side.

channel catfish

The most commonly fished U.S. catfish is one of hundreds of diverse, international species that share the name. Like this "channel cat," most are freshwater, bottom-feeding fish with whisker-like organs called barbels, and skin or plates instead of scales.

Atlantic cod

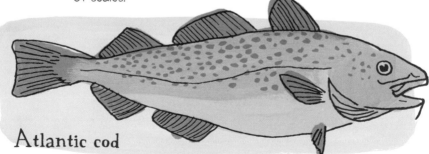

A cold-water, deep-sea fish with mild, flaky flesh that for centuries has been salted, dried, then shipped around the globe, leading to a worry the species is on the verge of disappearing.

How to Fillet a Fish

Make a deep cut just behind the head about halfway through the fish to the spine.

Working from the head toward the tail, slide the knife along the backbone of the fish all the way to the tail to make your fillet.

To remove the skin, cut a small piece away at a corner of the tail end and then run your knife between the tail and the flesh, cutting from the tail toward the head while holding the flesh taut in one hand.

Repeat on the other side of the fish to make your second fillet, making sure to remove any pinbones.

REGAL ROE

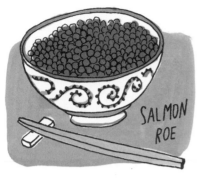

SALMON ROE

The roe, or eggs, from many kinds of fish and shellfish are eaten around the world as nutrient-packed delicacy.

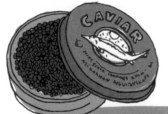

SHAD ROE

The term roe refers not to the individual egg but the collective egg masses, which are sometimes fried.

CAVIAR

Caviar traditionally refers only to the roe from wild sturgeon from the Caspian or Black seas — the Beluga, Sterlet, Ossetra, and Sevruga species, in order of their desirability.

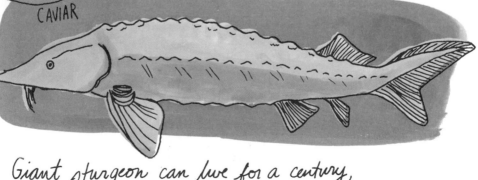

CAVIAR

Giant sturgeon can live for a century, and it often takes nearly two decades for them to start producing eggs.

OTHER EDIBLE SEA CREATURES

MAKING CALAMARI

Cephalopods

Squid, octopus, and cuttlefish are a type of mollusk with symmetrical bodies, big heads, and tasty tentacles.

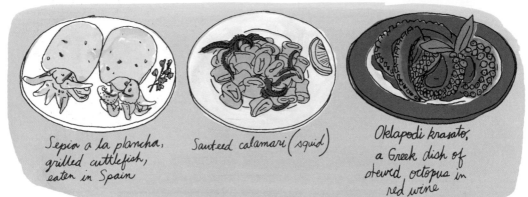

Sepia a la plancha, grilled cuttlefish, eaten in Spain

Sautéed calamari (squid)

Oklapodi krasato, a Greek dish of stewed octopus in red wine

Bivalves

Clams, oysters, scallops, cockles, and mussels are mollusks known for their hinged shells. Many bivalves are famously eaten "on the half-shell."

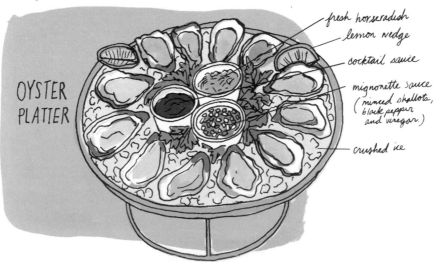

OYSTER PLATTER

fresh horseradish
lemon wedge
cocktail sauce
mignonette sauce (minced shallots, black pepper and vinegar)
crushed ice

Crustaceans

Crab, lobster, shrimp, krill, and crayfish have exoskeletons — in other words, their bones are on the outside of their bodies.

PERCEBES
(GOOSE BARNACLES)

mussels

In Spain and Portugal, people eat barnacles, a common crustacean.

Crab claw

break + pull

break + pull

slide meat out

break + pull

cut here

EATING CRAB CLAW

Shrimp cocktail

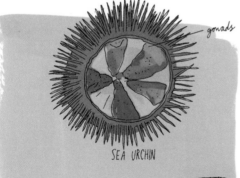

SEA URCHIN

gonads

Echinoderms

Starfish are the most recognizable members of this family, all of which have 5-point radial symmetry, but sea urchins and sea cucumbers are the most widely consumed.

The edible part of a sea urchin — in Japanese, it's called uni — is actually its soft orange gonads.

Spiky sea cucumber soaked in vinegar — served in China at celebrations

Uni Ikura Donburi — uni with roe over rice

THE FISHMONGER'S LEXICON

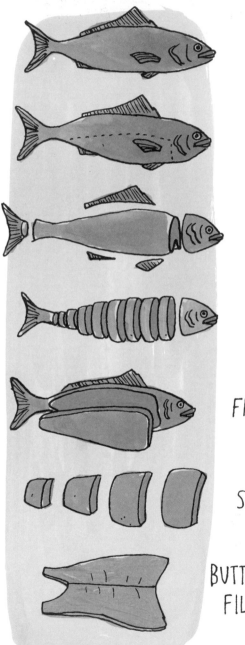

WHOLE — all parts intact

DRAWN — whole fish, internal organs removed

DRESSED — Scaled; head, tail, fins, and internal organs removed

STEAKS — Vertical cuts from the whole fish

FILLET — Horizontal cuts from one side of the fish

STICKS — Sections of fillets

BUTTERFLY FILLET — Also known as split; cut open lengthwise, backbone removed, and opened flat, for stuffing or for quick cooking

SEAFOOD COOKERY TOOLS

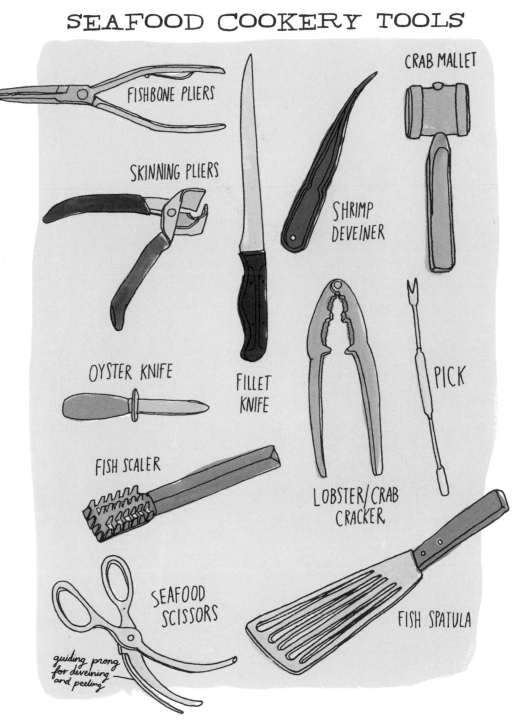

FISHBONE PLIERS

CRAB MALLET

SKINNING PLIERS

SHRIMP DEVEINER

OYSTER KNIFE

FILLET KNIFE

PICK

FISH SCALER

LOBSTER/CRAB CRACKER

SEAFOOD SCISSORS

guiding prong for deveining and peeling

FISH SPATULA

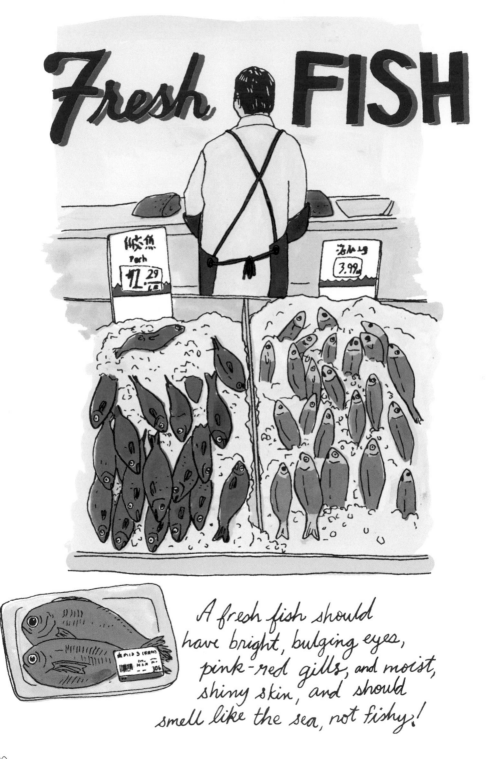

A fresh fish should have bright, bulging eyes, pink-red gills, and moist, shiny skin, and should smell like the sea, not fishy!

COMMONLY EATEN CLAMS

CLAM RAKE

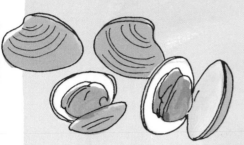

LITTLENECK

These hard-shell clams — Northeasterners sometimes call them quahogs — are the same clam as top necks, cherrystones, and chowders, just harvested when they're smaller.

IPSWICH

Also called soft-shell clams or steamers, these Atlantic Coast clams are named for Ipswich, MA. They have lighter colored, oblong, brittle shells and are sometimes fried whole and sold as "clam bellies."

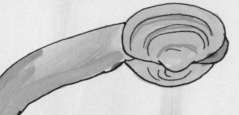

GEODUCK

Pronounced gooey-duck, this extra-large clam has a long, thick neck that occasionally spurts water; it's generally sliced before being served raw or cooked.

MANILA

Originally from Asia, these smaller clams typically have a striped, hard shell.

RAZOR

One of many clams with long, thin shells that look a little like a straight razor.

KINDS OF SUSHI

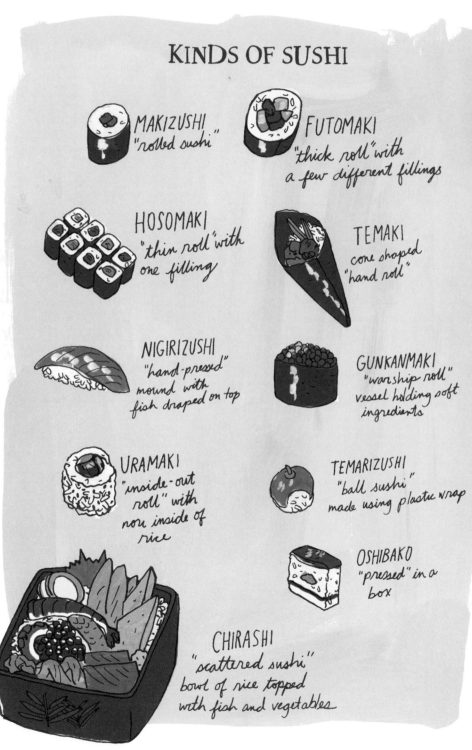

MAKIZUSHI
"rolled sushi"

FUTOMAKI
"thick roll" with
a few different fillings

HOSOMAKI
"thin roll" with
one filling

TEMAKI
cone shaped
"hand roll"

NIGIRIZUSHI
"hand-pressed"
mound with
fish draped on top

GUNKANMAKI
"warship roll"
vessel holding soft
ingredients

URAMAKI
"inside-out
roll" with
nori inside of
rice

TEMARIZUSHI
"ball sushi"
made using plastic wrap

OSHIBAKO
"pressed" in a
box

CHIRASHI
"scattered sushi"
bowl of rice topped
with fish and vegetables

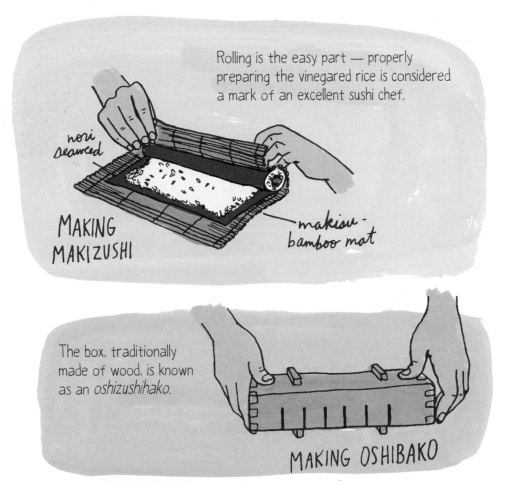

Rolling is the easy part — properly preparing the vinegared rice is considered a mark of an excellent sushi chef.

nori seaweed

MAKING MAKIZUSHI

makisu – bamboo mat

The box, traditionally made of wood, is known as an *oshizushihako*.

MAKING OSHIBAKO

Cooks in Japan have to be licensed to prepare sushi from the poisonous fugu, or puffer fish. Unless properly treated, its organs contain toxins that can paralyze or even kill diners.

Fugu sashi – puffer fish sashimi

ON THE SUSHI MENU

UNI
Sea Urchin

KURA
Salmon Roe

TAKO
Octopus

ANAGO
Conger Eel

SUMI-IKA
Cuttlefish

SHISO

WASABI

This rare and expensive root, primarily grown in Japan, is hard to grow, requiring a rocky stream or riverbed. The best sushi restaurants prepare it fresh — once grated, it loses its complex flavor in just fifteen minutes. More often than not, it's replaced by either prepared wasabi paste, a mix of flavored powder and water, or dyed horseradish root, a close relative.

SHISO

A fragrant herb in the mint family that's similar to basil, with hints of citrus and anise, it's used as a garnish, mixed into rice or soups, and occasionally layered into sushi itself.

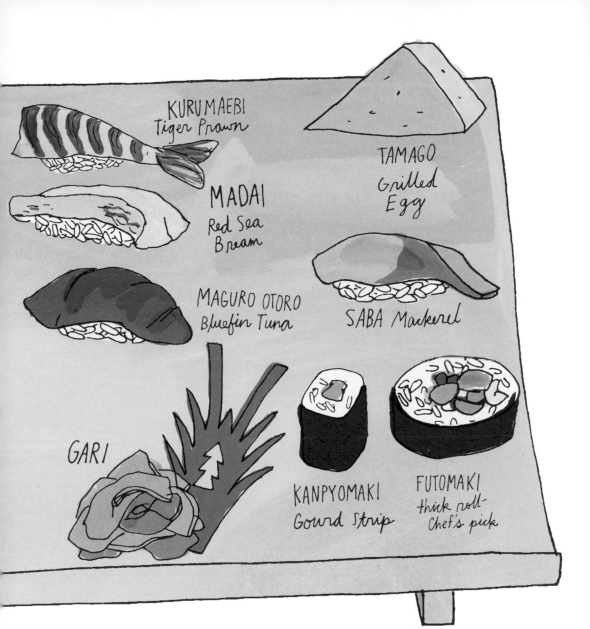

KURUMAEBI
Tiger Prawn

TAMAGO
Grilled
Egg

MADAI
Red Sea
Bream

MAGURO OTORO
Bluefin Tuna

SABA Mackerel

GARI

KANPYOMAKI
Gourd Strip

FUTOMAKI
thick roll-
Chef's pick

GARI

These thin slices of young pickled ginger are used a palate cleanser. Naturally a pale rose color, the hot pink versions are dyed.

Soy sauce is used sparingly. Only the fish side should be lightly dipped, never the rice.

EATING THE WHOLE CHICKEN

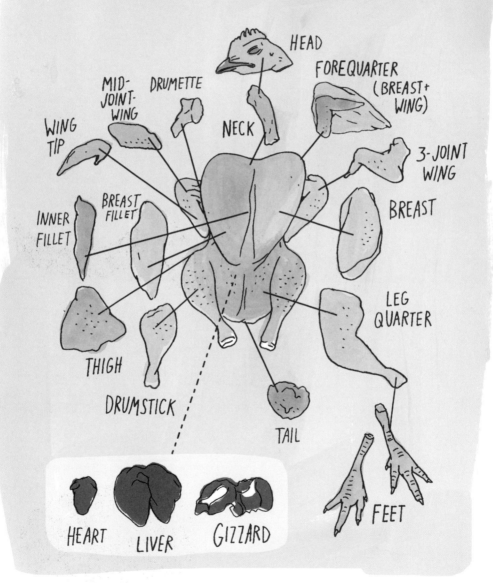

HEAD

FOREQUARTER
(BREAST +
WING)

MID-
JOINT-
WING

DRUMETTE

NECK

WING
TIP

3-JOINT
WING

BREAST
FILLET

BREAST

INNER
FILLET

LEG
QUARTER

THIGH

DRUMSTICK

TAIL

FEET

HEART LIVER GIZZARD

POULTRY TERMS

broiler domesticated, hybridized chickens bred for meat

capon a castrated rooster

cornish a cross between the Cornish Game and Plymouth or White Rock chicken breeds

Poussin In the U.K., a young female chicken; in the U.S., a Cornish hen

Pullet young chickens bred for egg-laying, in the stage between chicks and hens

squab a young, domesticated pigeon

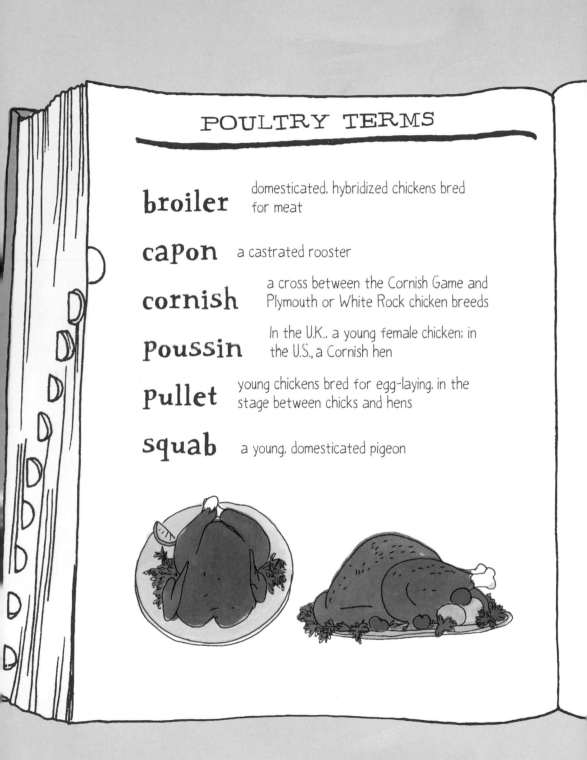

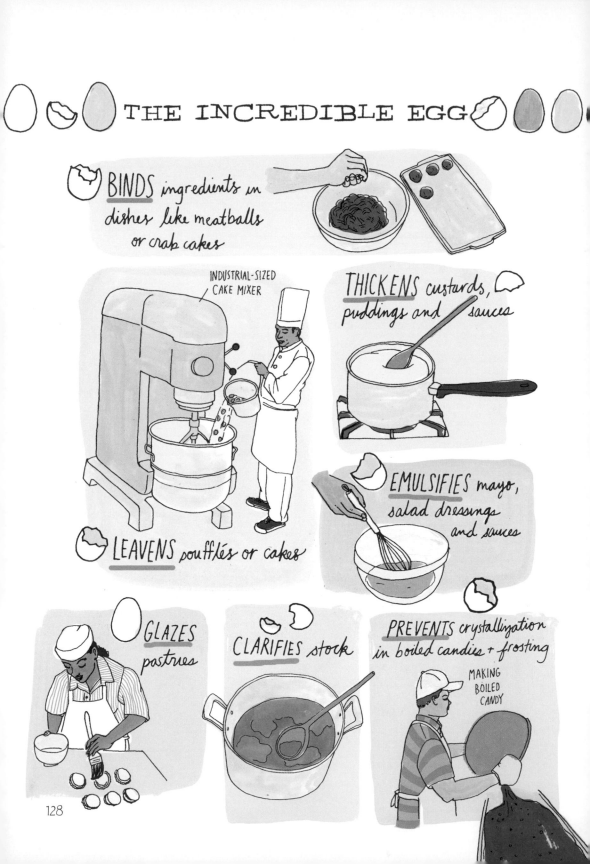

THE INCREDIBLE EGG

BINDS ingredients in dishes like meatballs or crab cakes

INDUSTRIAL-SIZED CAKE MIXER

THICKENS custards, puddings and sauces

LEAVENS soufflés or cakes

EMULSIFIES mayo, salad dressings and sauces

GLAZES pastries

CLARIFIES stock

PREVENTS crystallization in boiled candies + frosting

MAKING BOILED CANDY

128

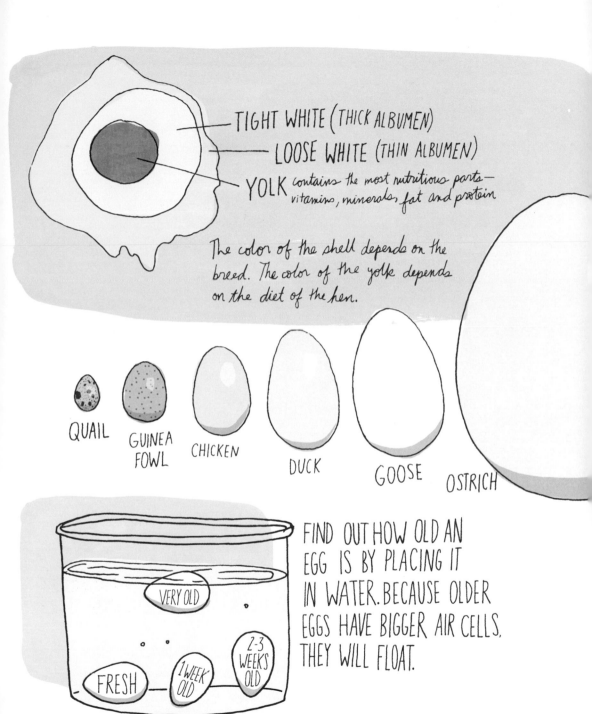

TIGHT WHITE (THICK ALBUMEN)

LOOSE WHITE (THIN ALBUMEN)

YOLK contains the most nutritious parts— vitamins, minerals, fat and protein

The color of the shell depends on the breed. The color of the yolk depends on the diet of the hen.

QUAIL

GUINEA FOWL

CHICKEN

DUCK

GOOSE

OSTRICH

VERY OLD

FRESH

1 WEEK OLD

2-3 WEEKS OLD

FIND OUT HOW OLD AN EGG IS BY PLACING IT IN WATER. BECAUSE OLDER EGGS HAVE BIGGER AIR CELLS, THEY WILL FLOAT.

SHORT ORDER EGG LINGO

ADAM + EVE
ON A LOG

ADAM + EVE
ON A RAFT

ADAM + EVE
ON A RAFT
AND WRECK 'EM

CLUCK + GRUNT

COWBOY
WESTERN

DROWN THE KIDS
(boil the eggs)

ETERNAL TWINS

FRY TWO
LET THE
SUN SHINE

FAMILY
REUNION

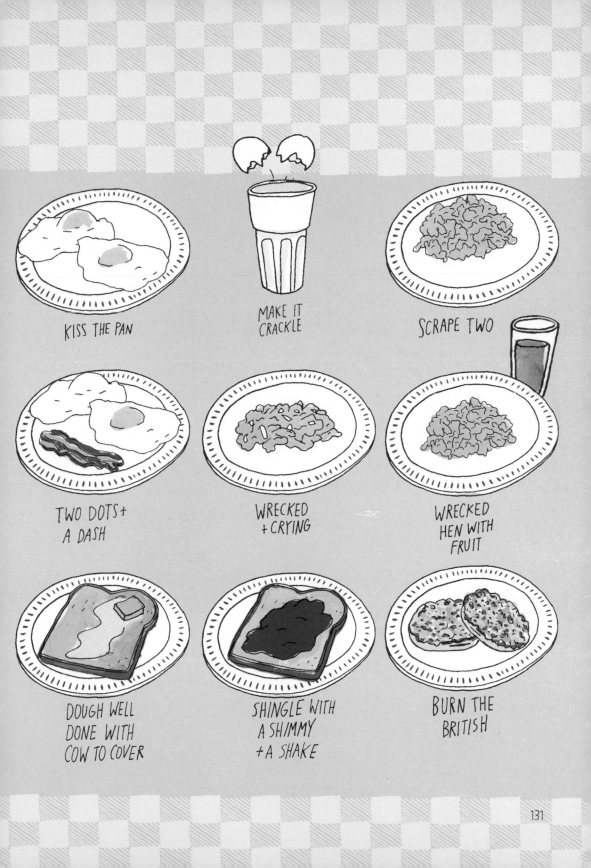

KISS THE PAN

MAKE IT
CRACKLE

SCRAPE TWO

TWO DOTS +
A DASH

WRECKED
+ CRYING

WRECKED
HEN WITH
FRUIT

DOUGH WELL
DONE WITH
COW TO COVER

SHINGLE WITH
A SHIMMY
+ A SHAKE

BURN THE
BRITISH

CHAPTER 5

Dairy Queens

MILK MAID MATH

AVERAGE PERCENTAGE OF BUTTERFAT

EUROPEAN BUTTER — 82-86%

AMERICAN BUTTER — 80%

CREAM — 45%

HEAVY CREAM — 36%

MEDIUM CREAM — 30%

LIGHT CREAM — 18-30%

HALF & HALF — 10.5-18%

WHOLE MILK — 3.25%

REDUCED FAT MILK — 2%

BUTTERMILK — 1-2%

LOW-FAT MILK — 1%

SKIM MILK — 0-0.5%

TERMS OF THE TRADE

buttermilk the liquid that remains after butter forms

cream the fat solids that rise to the top after the milk settles

cultures bacteria that change milk sugar (lactose) into lactic acid; used to make yogurt, buttermilk, and many types of cheese

curds the soft solids that form after rennet is added to milk

homogenization a process that breaks up milk fat and distributes it evenly to prevent the cream from rising to the top

pasteurization the process of briefly heating raw milk to at least 145°F and then cooling it quickly to increase shelf life

raw milk fresh from the cow (or goat or sheep) and has not been pasteurized

rennet contains enzymes that cause milk to coagulate and form cheese

whey the liquid by-product of cheese or yogurt making; it can be used to make other cheeses, such as ricotta

BAKING TIP: In a pinch, make "acidified buttermilk" by adding 1 tablespoon of vinegar or lemon juice to 1 cup of milk and letting it sit until it curdles, about ten minutes.

DELICIOUS DAIRY

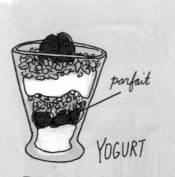

parfait

YOGURT

This cultured product forms when a starter is added to milk; the end result contains probiotics that promote good digestion and overall health.

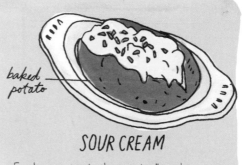

baked potato

SOUR CREAM

Fresh, unpasteurized cream is allowed to sour at room temperature; naturally occurring bacteria cause the thick texture and tangy flavor. Today it's often made commercially with the addition of bacterial cultures.

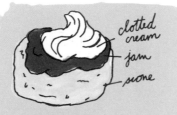

clotted cream
jam
scone

CLOTTED CREAM

Also called Devonshire or Cornish cream, this delicious British product is made by steaming and slowly cooling high-fat cow's milk so that the fat rises to the top and "clots."

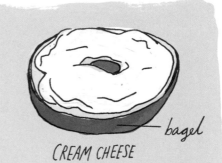

bagel

CREAM CHEESE

This high-fat (33%), high-moisture, spreadable cheese made of cow's milk was invented not in Philadelphia but in New York State.

CRÈME FRAÎCHE

Made with a technique similar to sour cream, this tangy topping is looser in consistency, tastes less sour, and has a higher fat content.

CLABBER

An old-fashioned ingredient once used as a leavener, it's made by letting unpasteurized milk sour over a few days until thick. It can be eaten sweet or savory, just like yogurt.

COTTAGE CHEESE

This simple cheese is made by heating milk with rennet and buttermilk until it forms solid curds and then pressing out the whey.

pizza

ricotta

RICOTTA

Traditionally made by heating leftover whey from the cheese-making process until the remaining protein solidifies into soft, fluffy curds, today ricotta typically comes from milk heated with an acidulant until it separates into curds and whey.

FARMER'S CHEESE

In the United States, pressed cottage cheese can be made with cow, sheep, or goat's milk.

HOW TO MAKE BUTTER IN THREE EASY STEPS

STEP 1

Whip the the best-quality heavy cream you can find with a mixer or in a food processor until yellow curds begin to separate from the buttermilk. (You will need at least two cups of heavy cream to yield 1 cup of buttermilk.)

STEP 2

Strain off the buttermilk from the curds. (Save it to make pancakes.)

STEP 3

Form the curds into a ball, and knead them with a wooden spoon to remove as much buttermilk as possible.

Real Deal Buttermilk Pancakes

2 CUPS OF FLOUR
2 TABLESPOONS SUGAR
4 TEASPOONS BAKING POWDER
1 TEASPOON BAKING SODA
1 TEASPOON FINE SEA SALT
2 CUPS REAL BUTTERMILK
4 TABLESPOONS UNSALTED BUTTER, MELTED
2 LARGE EGGS, BEATEN
VEGETABLE OIL, COOKING SPRAY OR BUTTER

1. Preheat a griddle or large skillet to medium-high heat, or until a drop of water dances on the surface but doesn't immediately steam away.

2. In a large mixing bowl, stir together the flour, sugar, baking soda, baking powder, and salt.

3. In a medium mixing bowl, whisk together the buttermilk, melted butter, and beaten eggs.

4. Add the buttermilk mixture to the dry ingredients and stir until just combined — you should have a few lumps.

5. Grease the griddle with oil, spray, or butter. Cook pancakes a few at a time — adding more oil as necessary — flipping them once after the bottoms have browned and bubbles form on the top. Serve with syrup or jam.

Cut the Cheese

A great cheese plate displays a range of flavors, textures, shapes, and colors. Use cheeses made from different types of milk, of different ages, all cut into different shapes. It also demands accompaniments, usually sweet ones: Try a few types of excellent honey, fig or other fruit preserves, or a selection of dried fruits and nuts.

Cut along dotted line.

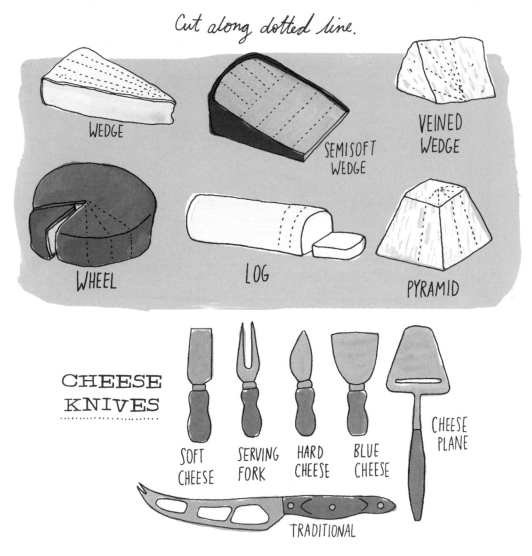

WEDGE

SEMISOFT WEDGE

VEINED WEDGE

WHEEL

LOG

PYRAMID

CHEESE KNIVES

SOFT CHEESE

SERVING FORK

HARD CHEESE

BLUE CHEESE

CHEESE PLANE

TRADITIONAL

CHEESE ANATOMY

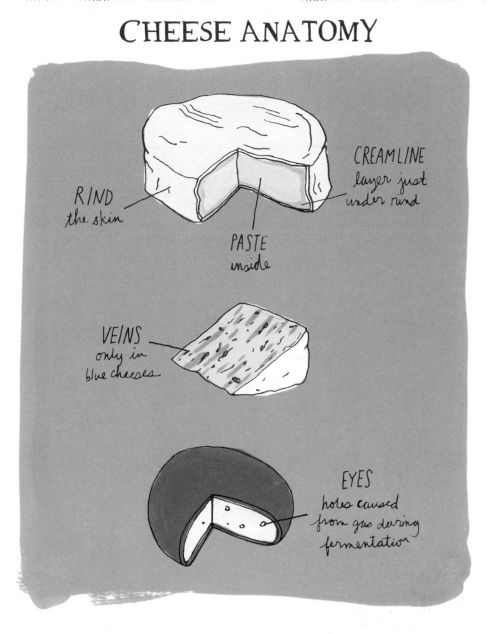

RIND
the skin

CREAMLINE
layer just
under rind

PASTE
inside

VEINS
only in
blue cheeses

EYES
holes caused
from gas during
fermentation

The Basic Steps in Making Cheese

1. HEAT THE MILK

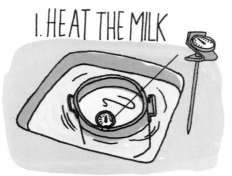

2. ADD STARTER

The starter is made of active bacteria that convert lactose to lactic acid and help control the rate of ripening.

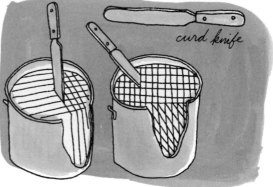

3. ADD RENNET

Rennin is an enzyme that helps the milk coagulate and form into the curd.

4. CUT THE CURDS

curd knife

5. COOK THE CURDS

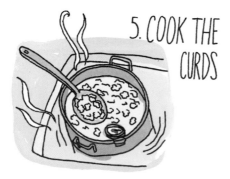

6. DRAIN THE CURDS

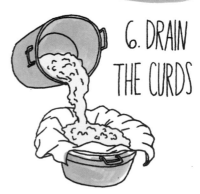

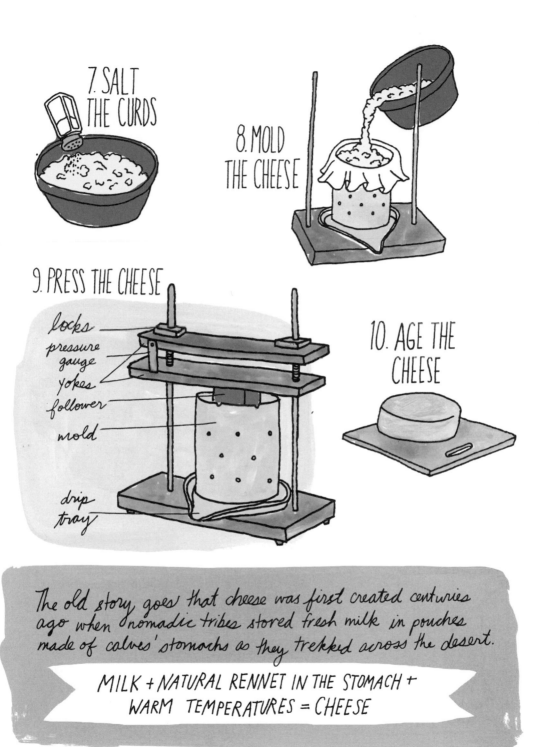

7. SALT THE CURDS

8. MOLD THE CHEESE

9. PRESS THE CHEESE

locks
pressure gauge
yokes
follower
mold
drip tray

10. AGE THE CHEESE

The old story goes that cheese was first created centuries ago when nomadic tribes stored fresh milk in pouches made of calves' stomachs as they trekked across the desert.

MILK + NATURAL RENNET IN THE STOMACH + WARM TEMPERATURES = CHEESE

TYPES OF CHEESE

Cheese can be made from the milk of any mammal — buffalo, horses, even yaks and camels — though cow, goat, and sheep's milk cheeses are the most common. Beyond type of milk, there are many ways to classify a cheese, but cheesemongers recognize these categories.

Fresh

Young, soft, moist cheeses that are not aged, or only cured for a very short period.

GOAT

MOZZARELLA

Bloomy Rind

Has a soft, sometimes fuzzy, mushroomy, edible white rind resulting from the introduction of molds to the outside of a cheese. These are also often called soft-ripened because they are ripened from the outside in.

BRIE

CAMEMBERT

In Europe these young cheeses are traditionally made with raw milk, but in the U.S., it's illegal to sell raw milk cheeses that have not been aged for at least 60 days.

Washed Rind

TALEGGIO

Any cheese with a rind washed or moistened with anything from saltwater to beer or bourbon that fosters growth of flavor and aroma-producing bacteria, creating so-called "stinky cheese." (You don't have to eat the rind!)

EPOISSES

Semi Soft

Cheeses with a range of flavors that are generally smooth, moist, and creamy on the inside with little or no rind.

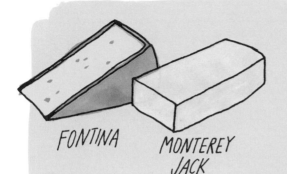

FONTINA

MONTEREY JACK

CHEDDAR

Firm / Hard

These cheese are generally aged longer, have a thicker rind you probably don't eat, and are intensely flavored rather than mild or creamy. Many cheeses like Cheddar or Gouda are found in firm and hard forms, depending on how long they are aged.

PARMIGIANO-REGGIANO

GOUDA

These cheeses are all PDO, a European certification meaning "protected designation of origin," that is granted to agricultural products that represent a certain region and are made to a certain standard.

Blue

The veins or marbling are created by mold cultures injected into the cheeses as they're made. Most are complex, sharp, and salty-sweet.

ROQUEFORT

GORGONZOLA

AMERICAN CHEESE

American cheese is generally made by heating and mixing particles of other types of cheese. Real American cheese — or "pasteurized process American cheese," depending on how many types of cheeses are used — is mainly cheese, plus a small amount of acid (to keep the pH low and bacteria at bay), some extra cream or milk fat, water, salt, coloring, and spices. If more of those and other ingredients such as dairy by-products, emulsifiers, and oil are added, it must be labeled "process cheese food" (like Velveeta) or "process cheese product" (like Cheez Whiz, sold as either a spread or a sauce).

American cheeses and their ilk are high-moisture cheeses, which is one reason why they melt so easily. The less moisture in a cheese, the more it'll separate when heated. Of course the addition of cream, water and, in some cases, oil or emulsifiers to keep the product smooth and consistent also helps.

grilled cheese sandwich

CURD NERDISMS

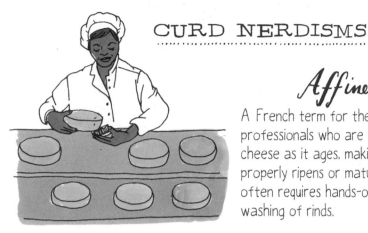

Affineur

A French term for the experienced professionals who are responsible for a cheese as it ages, making sure it properly ripens or matures. This role often requires hands-on care, such as washing of rinds.

Cheddar

When used as a verb, a cheesemaking technique that describes a method of stacking and turning curds to ensure they're evenly pressed, resulting in a smooth, firm texture.

Transhumance

Despite its name, this is the tradition of moving livestock, not people, from one grazing area to another as seasons change, typically to low ground in winter and highlands in summer. In the Alps, this results in some of the world's best cheeses and spectacular fall festivals.

Pasta Filata

An Italian term for the cheesemaking technique behind mozzarella, caciocavallo, provolone, and other cheeses. The curds for these cheeses are stretched, pulled, or kneaded.

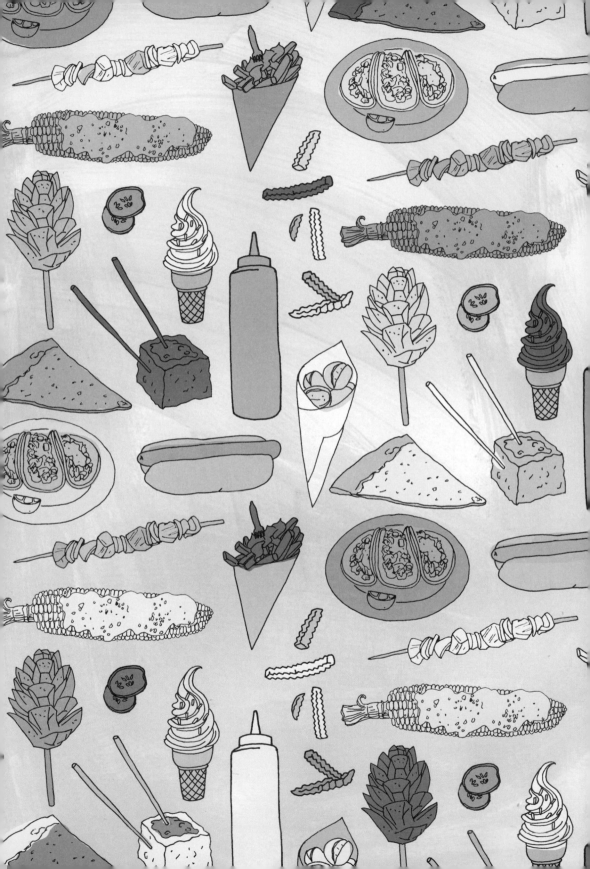

CHAPTER 6

Street
Food

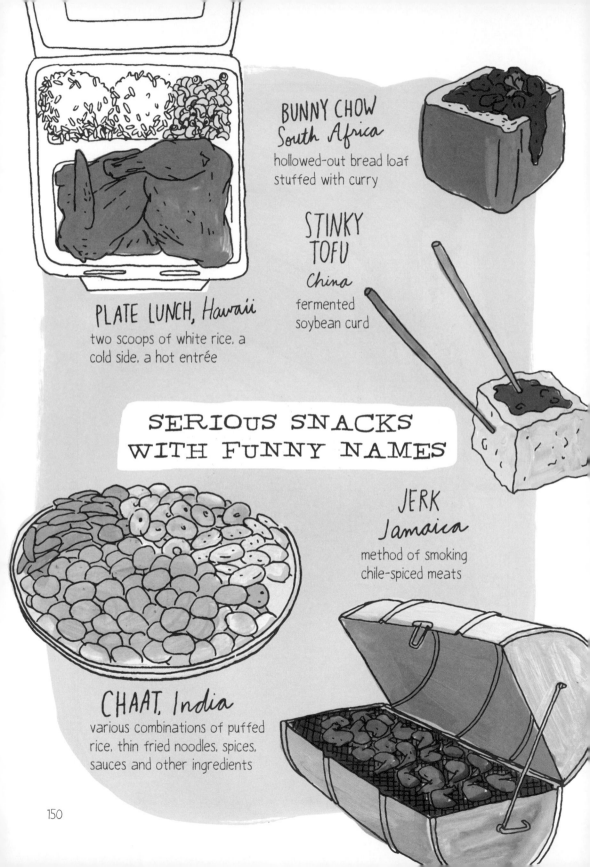

BUNNY CHOW
South Africa

hollowed-out bread loaf
stuffed with curry

STINKY
TOFU
China

fermented
soybean curd

PLATE LUNCH, Hawaii

two scoops of white rice, a
cold side, a hot entrée

SERIOUS SNACKS WITH FUNNY NAMES

JERK
Jamaica

method of smoking
chile-spiced meats

CHAAT, India

various combinations of puffed
rice, thin fried noodles, spices,
sauces and other ingredients

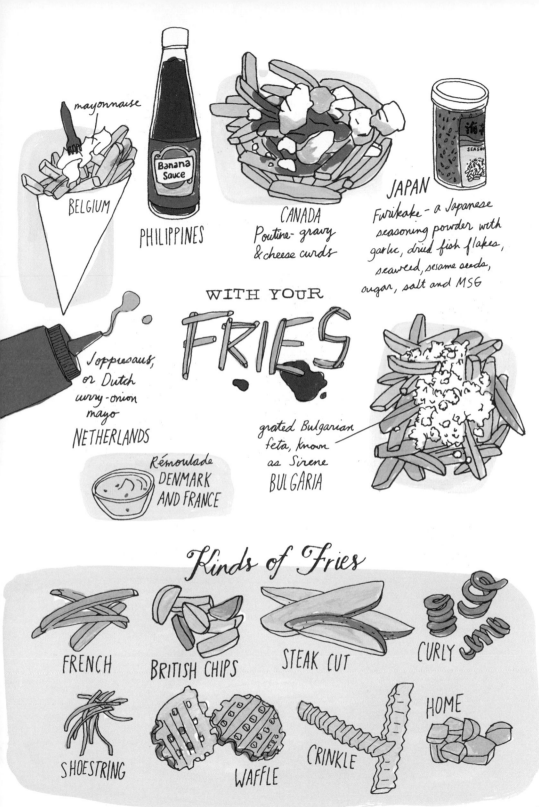

mayonnaise

BELGIUM

Banana Sauce

PHILIPPINES

CANADA
Poutine- gravy
& cheese curds

JAPAN
Furikake - a Japanese
seasoning powder with
garlic, dried fish flakes,
seaweed, sesame seeds,
sugar, salt and MSG

WITH YOUR

FRIES

Joppiesaus,
or Dutch
curry-onion
mayo
NETHERLANDS

grated Bulgarian
feta, known
as Sirene
BULGARIA

Rémoulade
DENMARK
AND FRANCE

Kinds of Fries

FRENCH

BRITISH CHIPS

STEAK CUT

CURLY

SHOESTRING

WAFFLE

CRINKLE

HOME

HOTDAWG!

CHILEAN COMPLETO

mashed avocado, mayo, diced tomatoes, and sauerkraut, with the chile-pepper condiment called pebre on the side

COLOMBIAN PERRO CALIENTE

toppings usually include but are not limited to: pineapple chunks, a Russian-dressing-like pink sauce, ketchup, crushed potato chips, and cheese

BRAZILIAN COMPLETO

seasoned ground beef, shredded carrots, diced ham, potato sticks, canned corn, hard-boiled eggs, cilantro, and a mix of chopped bell peppers, tomatoes, and onions

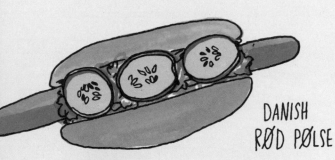

DANISH RØD PØLSE

or "red sausage," a skinny deep red wiener served with raw onions, rémoulade, and sliced cucumbers

ICELANDIC PYLSUR

fried dried onions and pylsusinnep (sweet brown mustard) on a frank made of lamb

NYC "DIRTY WATER" DOG

simmered in water and sold from carts, topped with brown mustard, sauerkraut, and tomatoey sweet onion sauce

LA STREET DOG

bacon-wrapped, often topped with various items including grilled onions, diced tomato, and a whole roasted chile pepper

FIVE STYLES OF MEAT

ON A STICK

ESPETINHO

"little skewer" in Brazilian Portuguese, and filled with almost anything you can think of and grilled over charcoal. Usually served with hot sauce and farinha, or crunchy coarsely ground flour.

CHISLIC

a South Dakota specialty of grilled cubed meats — venison, lamb, mutton, etc. — spiced and served on toothpicks with saltine crackers and garlic powder

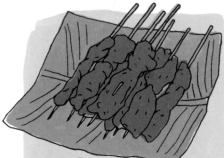

SATE

meats marinated in coconut milk, turmeric, and other spices, served with peanut sauce and pickled vegetables, traditionally grilled on a banana leaf rib in Southeast Asia

ANTICUCHOS

Peruvian meats, typically beef hearts, marinated in vinegar, chile, cumin, and garlic and skewered with a potato or piece of bread

ARROSTICINI

skewers of mutton from the Abruzzo region of Italy that are cooked on a special long grill called a canala, after its canal-like shape

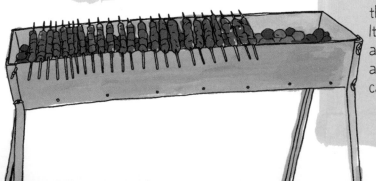

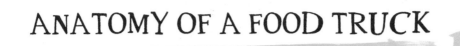

ANATOMY OF A FOOD TRUCK

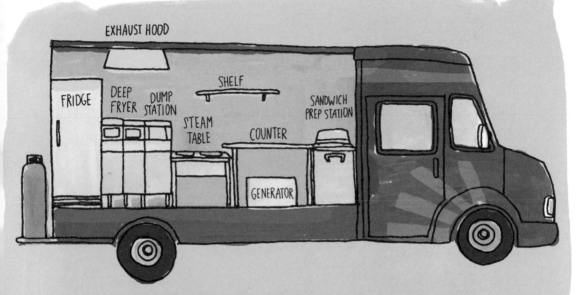

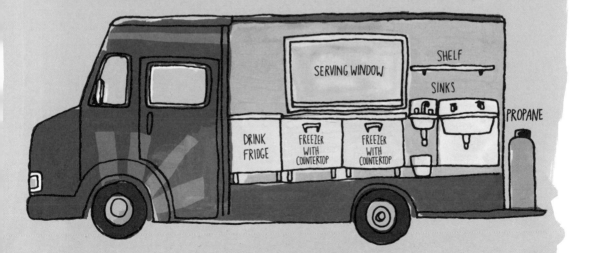

Based on plans from Prestige Food Trucks.com

ON THE STREETS...

Italian Chestnut Roasting Pan

Beijing Má là tāng Stall

Málàtāng is a spicy broth with a variety of added ingredients.

Mexican Ambulantes

Platanos are fried plantains.

PLATANOS

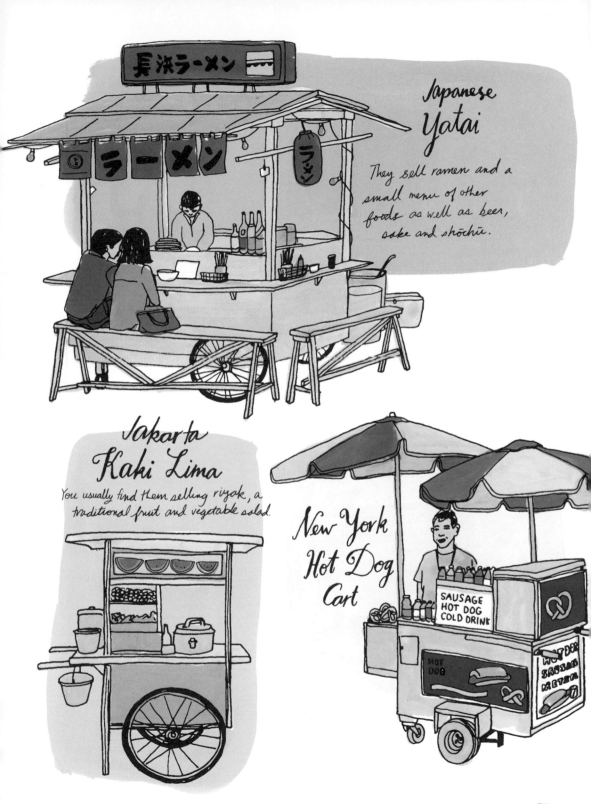

長浜ラーメン

ラーメン

Japanese
Yatai

They sell ramen and a small menu of other foods as well as beer, sake and shōchū.

Jakarta
Kaki Lima

You usually find them selling rijak, a traditional fruit and vegetable salad.

New York
Hot Dog
Cart

SAUSAGE
HOT DOG
COLD DRINK

HOT DOG

HOT DOG
SAUSAGE
PRETZEL

PIZZA, PIZZA!

New York Slice

Sold at small pizza places on every street, this plain cheese slice usually costs little more than a dollar.

Sicilian Pizza Slice

In America, this is a thick square pie with a crunchy base and generally a fluffy, airy, almost bready crust.

New Jersey Tomato Pie

A thick, dense crust is topped with a thick layer of crushed tomatoes and a small amount of grated cheese, similar in style to the sfincione made in the Sicilian city of Palermo.

Chicago Deep Dish

Pizza cooked in a deep-sided pie pan; the cheese generally goes underneath the toppings with the sauce on top.

Pizza al Taglio

This Roman-style pizza is baked in long rectangular pans in electric ovens and often cut with scissors and sold by weight.

Detroit Deep Dish

A thick, chewy crusted pizza related to the Sicilian, baked in a well-oiled pan so that the crust appears almost fried; it is sometimes baked twice.

Neapolitan Pizza Margherita

Originating near the Italian city of Naples, with a puffy crust made possible in part by quick cooking in a wood-fired oven, this pizza should be made with basil, tomatoes from San Marzano, and buffalo milk mozzarella from Campania.

St. Louis Pizza

It has cracker-thin crust topped with Provel (a white processed-cheese blend of cheddar, Swiss, and provolone) and is cut into squares.

TAQUERIA TERMINOLOGY

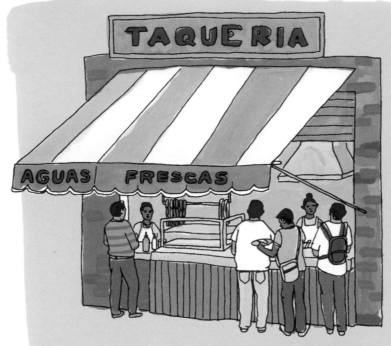

TACOS DE... **BUCHE** - pig stomach
CABEZA - cow head
LENGUA - beef tongue
ARABES - spicy ground lamb wrapped tightly in a flour tortilla

TORTA

a sandwich of almost any kind, usually dressed with beans, chile, and avocado, and often served on a soft, split-top roll called a telera

SUADERO

thin cuts of beef taken from between the belly and the upper thigh, often cooked on a special domed griddle

TLAYUDA

a large crispy tortilla topped with beans, lard, and other toppings, especially mozzarella-like strands of Oaxacan cheese

GORDITA DE CHICHARRÓN

a fried plump cake of masa (gordita is "chubby" in Spanish) filled with chile-stewed pork rinds

ALAMBRE

a mixed grill of meats, onions, peppers, and melty cheese served with a stack of tortillas

CHAPTER 7

Season to Taste

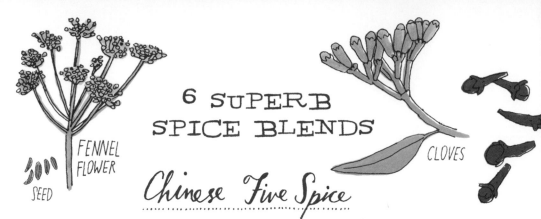

6 SUPERB SPICE BLENDS

FENNEL FLOWER
SEED

CLOVES

Chinese Five Spice

An aromatic blend with a little bit of heat thanks to the tongue-tingling sensation provided by the Szechuan peppercorns, which are unrelated to black pepper or chiles. This is usually used for rich meats or flavored oils, and ingredients vary by region.

Mix the following:

1 TABLESPOON GROUND CINNAMON
1 TABLESPOON GROUND CLOVES
1 TABLESPOON FENNEL SEED, TOASTED AND GROUND
1 TABLESPOON GROUND STAR ANISE
1 TABLESPOON SZECHUAN PEPPERCORNS, TOASTED AND GROUND

CINNAMON QUILLS

STAR ANISE

THYME

Za'atar

A tart spice blend usually made with thyme, sesame seeds, and the tiny, sour, dark-red fruit of the sumac plant, which are dried and ground into a powder. Za'atar is often sprinkled on warm bread topped with plenty of good extra-virgin olive oil.

Mix the following:

2 TABLESPOONS MINCED FRESH THYME
2 TABLESPOONS SESAME SEEDS, TOASTED
2 TEASPOONS GROUND SUMAC
1/2 TEASPOON SEA SALT

SESAME SEED PLANT

SUMAC

PEQUIN
PEPPERS

Nitmita

Not as well known as the more complex Ethiopian spice mix
called berbere. this blend of mostly chile is sprinkled on
beans or blended with clarified butter to make the raw
beef dish called "kitfo."

Grind the following into a fine powder.

½ POUND DRIED PEQUIN OR AFRICAN BIRD'S EYE CHILES
1 TABLESPOON BLACK CARDAMOM PODS, SHELLS REMOVED
AND SEEDS TOASTED
½ TABLESPOON WHOLE CLOVES, TOASTED
¼ CUP SEA SALT

CARDAMOM
PLANT

PODS SEEDS

Garam Masala

A go-to spice on the Indian subcontinent - garam roughly means "heat mix"–
it varies from cook to cook and has plenty of warming spices.

Toast the following until fragrant, then grind into a fine powder.

4 TABLESPOONS CORIANDER SEEDS
1 TABLESPOON CUMIN SEEDS
1 TABLESPOON BLACK PEPPERCORNS
1½ TEASPOONS BLACK CUMIN SEEDS
1½ TEASPOONS GROUND GINGER
SEEDS FROM 4 PODS OF BLACK CARDAMOM
25 WHOLE CLOVES
2-INCH PIECE OF CINNAMON STICK, CRUSHED
1 BAY LEAF, CRUSHED

CUMIN

GINGER

BAY LEAVES

165

CORIANDER SEEDS

CORIANDER

Harvaij

This all-purpose spice mix of Yemeni origin is added to soups, vegetables, roasted meats, or rice. Another version with anise, fennel, ginger, and cardamom is used to enhance coffee and tea.

Toast the following until fragrant, then grind into a fine powder.

ROOT

6 ½ TABLESPOONS BLACK PEPPERCORNS
¼ CUP CUMIN SEED
2 ½ TABLESPOONS CORIANDER SEEDS
1 ½ TABLESPOONS GREEN CARDAMOM PODS, CRUSHED
3 ½ TABLESPOONS GROUND TURMERIC

TURMERIC PLANT

CHILE PEPPER

Shichi-Mi Tōgarashi

Also known as seven-spice pepper, this is used as a table condiment and sprinkled atop soups and other food in Japan.

Toast the following (except for ground ginger, if using), and coarsely grind together.

SZECHUAN PEPPER

POPPY SEED PODS

3 TEASPOONS CHILE FLAKES
3 TEASPOONS JAPANESE SANSHO PEPPER OR SZECHUAN PEPPERCORNS
1 TEASPOON DRIED SEAWEED
3 TEASPOONS DRIED TANGERINE PEEL
2 TEASPOONS WHITE SESAME SEEDS, TOASTED
1 TEASPOON BLACK SESAME SEEDS, TOASTED
1 TEASPOON POPPY OR HEMP SEEDS, TOASTED, OR SUBSTITUTE GROUND GINGER

THAT'S HOT!

The key ingredient in any hot sauce is the chile, a fruit with a vast range of flavors that develop as peppers ripen. In many countries, unique chiles and hot sauces are foundational flavors of the cuisine.

CAYENNE

The hot, earthy, ripe red Cayenne chile, fermented with salt, barrel-aged, and diluted with vinegar, flavors the quintessential Louisiana-style hot sauce.

SCOTCH BONNET

In the West Indies, the floral Scotch Bonnet gets blended with vinegar or sour citrus juice, often with a little carrot and onion.

BIRD'S EYE

In southeast Asia, skinny, very hot and fruity Bird's Eye chiles are traditionally crushed with garlic, onions, and lime juice and diluted with fish sauce.

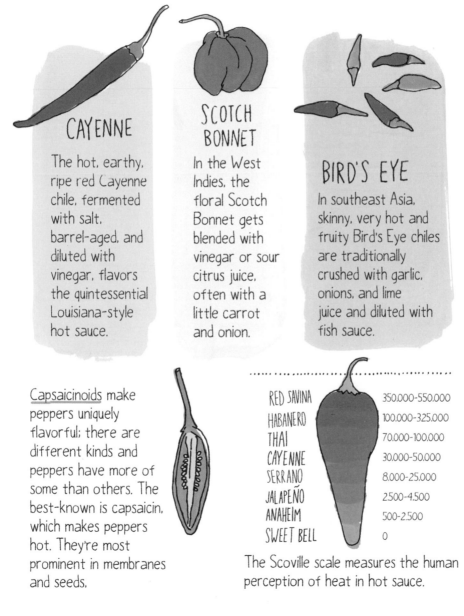

Capsaicinoids make peppers uniquely flavorful; there are different kinds and peppers have more of some than others. The best-known is capsaicin, which makes peppers hot. They're most prominent in membranes and seeds.

RED SAVINA	350,000-550,000
HABANERO	100,000-325,000
THAI	70,000-100,000
CAYENNE	30,000-50,000
SERRANO	8,000-25,000
JALAPEÑO	2,500-4,500
ANAHEIM	500-2,500
SWEET BELL	0

The Scoville scale measures the human perception of heat in hot sauce.

A LITTLE SOMETHING SWEET

AGAVE PLANT

Agave Syrup

Made from the same spiky-leaved plant family that gives us tequila and mescal, the unrefined version can be very dark and richly flavored with earthy minerals.

Honey

The biggest factor in the flavor of honey is actually the flower. The most prized varieties tend to be monofloral, meaning they come from bees that forage from a hillside full of lavender, say, or maybe a citrus grove, or a field of golden wheat. Mass-produced honey — blended from many sources, including bees fed sugar-water — is best used for sweetness, not flavor.

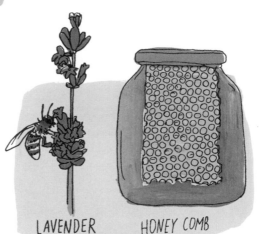

LAVENDER HONEY COMB

Honeycomb is both beautiful and edible. Try it on a cheese plate.

Cane Syrup

This dark, sweet, complexly flavored and mineral-rich sweetener made from reducing pressed sugarcane juice is a beloved product in Louisiana.

SUGARCANE STALK

Sugar

It is most often made from sugar beet or sugarcane juice boiled until it begins to form solid crystals, which are then dried. For white sugar, any remaining plant matter is also refined away until nothing is left but pristine, colorless grains.

Molasses

The brown, flavorful liquid left over from refining sugar, molasses can also be made from the juice of grapes, dates, pomegranates, and other sweet crops.

MOLASSES

SORGHUM

Corn Syrup

Chemically derived from cornstarch, it differs from light corn syrup, which is seasoned with vanilla flavor and salt; dark corn syrup (combined with molasses, caramel flavor, and salt); and high-fructose corn syrup, which was created to taste sweeter, dissolve easily, and hold moisture, making it ideal for processed foods.

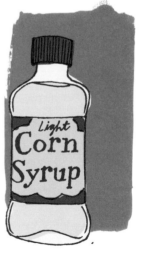

Light Corn Syrup

Sorghum Syrup

Less familiar to many Americans, it is squeezed from stalks of sorghum grass.

SUGAR HOUSE

In the Sugar House

Produced primarily in the northeast US and Canada, maple syrup is made by boiling down sap from sugar or black maple trees in early spring, just before they send out new leaves.

Sap becomes syrup at 7 degrees above the boiling point of water. It takes 40 to 80 gallons of sap to make a single gallon of syrup.

SPILES + BUCKETS

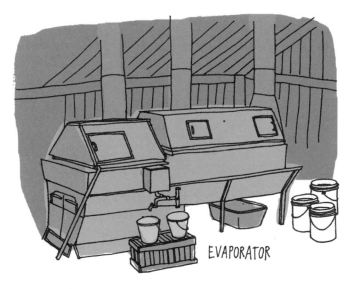

EVAPORATOR

SUGAR BUSH

a stand of sap-producing sugar maples

SPILES

the metal or plastic spouts or taps that are driven into a tree to send the sap dripping into the buckets

SUGAR HOUSE the building where the sap is boiled

EVAPORATORS giant shallow metal pans perched atop a fire fueled by wood or gas

GRADE A also called Vermont Fancy, is the lightest syrup in color and flavor. Sap collected later in the season when the tree buds swell produces darker syrup, or Grade B.

Creamy Maple Mocha Pudding

3 TABLESPOONS CORNSTARCH
1 TABLESPOON POWDERED INSTANT COFFEE
1 TEASPOON UNSWEETENED COCOA POWDER
PINCH OF SALT
3 EGGS YOLKS
3 CUPS MILK
½ CUP PURE MAPLE SYRUP
1 TABLESPOON UNSALTED BUTTER
1 TEASPOON VANILLA EXTRACT

1. In a large, heavy-bottomed pot, combine the cornstarch, coffee, cocoa, and salt; whisk to mix. In a mixing bowl, whisk the egg yolks slightly, then add the milk and maple syrup. Stir into the pot.

2. Over medium-high heat, gradually bring the mixture to a boil, stirring gently but constantly with a rubber spatula. Be sure to scrape the sides as you stir. Boil for 1 minute, stirring constantly. Remove from heat and stir in the butter and vanilla.

3. Ladle into four or five individual serving bowls. To prevent a skin from forming, place a piece of wax paper, cut to size, on top of each. Cool, then chill for several hours before serving.

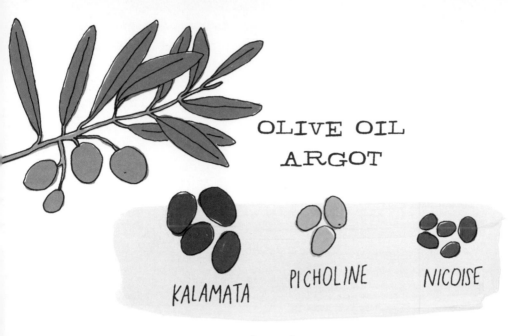

OLIVE OIL ARGOT

KALAMATA

PICHOLINE

NICOISE

Acidity

The International Olive Council grades olive oil first by acidity level — the lower it is, generally, the more complex the flavors and higher the antioxidants. Plain "olive oil" is around 2% acidity, "virgin" oil is 1.5%, and "extra-virgin" — the highest quality — is 0.8% acidity or lower.

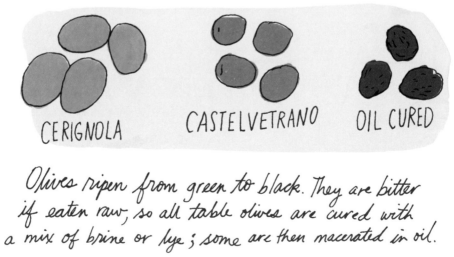

CERIGNOLA

CASTELVETRANO

OIL CURED

Olives ripen from green to black. They are bitter if eaten raw, so all table olives are cured with a mix of brine or lye; some are then macerated in oil.

First Cold Press

In truth all extra-virgin oil is first cold press — heat and multiple pressings yield lots of oil, but of low quality.

OLD STYLE OLIVE PRESS

Harvest Date

The best extra-virgin oil is pressed and bottled right after harvest. Some oils, however, are stored in stainless steel vats and bottled years later.

New Harvest

This is the very first pressing of oil for the harvest and the most intense in flavor. In the northern hemisphere, this pressing is done in fall; in the southern, the spring.

Unfiltered

Tiny particles of fruit are left in the bottle. It's often more flavorful, but be careful using this with heat — the particles can burn.

Country of Origin

The closer the harvest is to the bottler, the better. If the label mentions olives come from many countries, use the oil for cooking, not as a condiment. You might also see symbols like the European mark of PDO (protected designation of origin), which certifies that the oil represents a historical, regional style.

MUSTARD

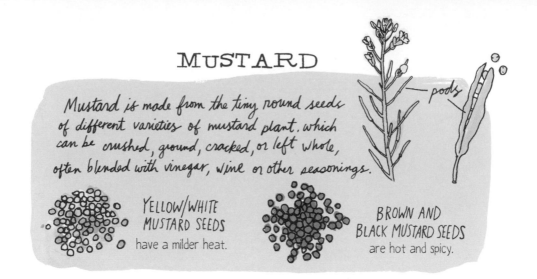

Mustard is made from the tiny round seeds of different varieties of mustard plant, which can be crushed, ground, cracked, or left whole, often blended with vinegar, wine or other seasonings.

pods

YELLOW/WHITE MUSTARD SEEDS have a milder heat.

BROWN AND BLACK MUSTARD SEEDS are hot and spicy.

In the Belgian city of Ghent is Tierenteyn-Verlent, a 225-year-old mustard shop founded by Adelaide Verlent, a widow who sold spices until a relative learned how to finely grind mustard seeds in France (a technique and style of white-wine mustard now known as Dijon, after the city where the style was perfected). The counters, jars and cabinets are all original, and you can still buy their sharp mustard to go in stoneware crocks stoppered with corks. Those and other vessels in various shapes and sizes are filled to order from ancient wooden mustard barrels.

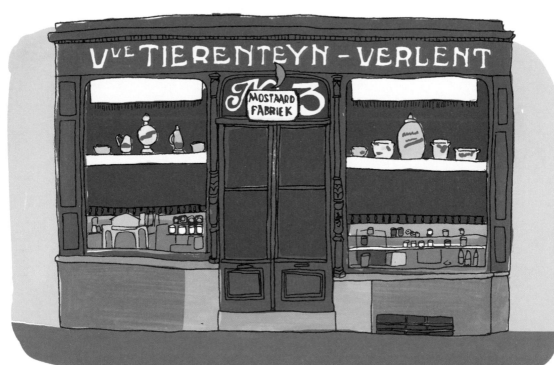

How to Make Vinegar in 5 Steps

1. Fill a glass container with good quality cider, beer, or wine.

2. Add a vinegar "mother," a small amount of natural vinegar that contains acetobacter, the bacteria that convert ethanol (alcohol) into acetic acid (vinegar). Most mothers come with a jellyfish-like blob that is actually cellulose, a by-product of fermentation. You can get one from a friend, or use one left behind in a bottle of naturally fermented vinegar. Any vinegar mother can theoretically work in any kind of alcohol, though they grow more accustomed to the alcohol they are in over time.

3. Cover the jar tightly with a clean dishtowel or a few layers of cheese-cloth. Set it aside in a place where the temperature won't go below freezing or above 90° F. The higher the temperature, the faster your alcohol ferments into vinegar. If you see mold at any point, best to throw it out and start again.

4. Now you wait, tasting every week. After a month, it should begin to taste like vinegar, and will start to grow more acidic over time. Pour off the vinegar when you like the taste, and then top off the jar with alcohol to make more.

5. To store your vinegar, you can either refrigerate it to slow down the fermentation process, or strain and heat it to 155°F to stop the fermentation altogether. This means you can store it at room temperature without a change in flavor. If you want to get fancy, you can age it further in wood barrels to mellow its flavor.

SALT

TABLE SALT

is refined into smooth, uniform, small grains and mixed with anti-caking agents and often potassium iodide, then sold as iodized salt.

KOSHER SALT

is essentially table salt with a larger, flakier grain size. It is not always certified kosher—today the name refers mainly to style, not substance.

SEA SALT

can cover a wide range of salts with varying qualities, but it is generally larger grained and flakier than table or kosher salt.

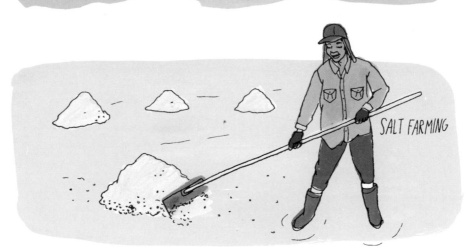

SALT FARMING

Salt nerds like to joke that technically all salt is sea salt, since it is either processed from salt mined from deposits under the earth — which were once great seas — or evaporated in one manner or another from sea water. Since antiquity, coastal salt makers have moved sea water throughout a series of small, shallow ponds until salt finally crystallizes into a thick crust on the top. Traditionally, this is raked together into baskets and then milled or ground into coarse or fine products.

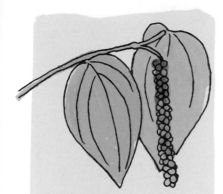

PIPER NIGRUM,
the pepper plant

PEPPER

White, green, and black peppercorns all come from the seeds of the same tropical vine, each with a similar but slightly different flavor. White peppercorns are ripe seeds with the skin removed; green are unripe and then treated so that they remain green; and black are unripe, often cooked, and then dried. There are many varieties of peppercorn plants grown around the tropics, each with their own sought-after flavor profile.

PINK TELLICHERRY MALABAR SARAWAK MUNTOK GREEN
 BLACK BLACK WHITE WHITE

Pepper Mills

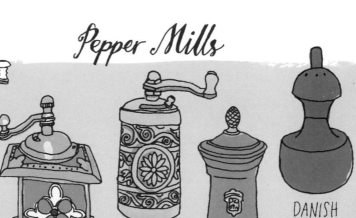

WELSH ITALIAN TURKISH FRENCH DANISH MODERN

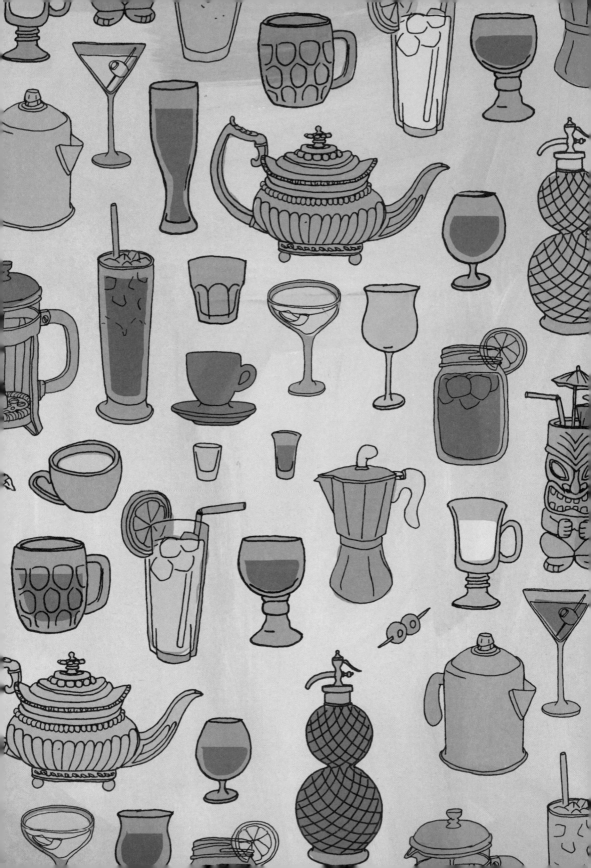

CHAPTER 8

Drink Up!

COFFEE

A coffee bean is the seed of the bright-red stone fruits produced by coffee trees. Inside the coffee cherries, as they are called, are "green" coffee beans, which are processed to remove their membrane and pulp, roasted, ground, and then brewed. These steps, as well as the way the tree is grown and where, create different flavors in coffee.

While there are also many different kinds of coffee beans, the two most commonly grown are Arabica and the Robusta varietals. Generally speaking, the former has more fruity flavor and acidity, the latter more caffeine.

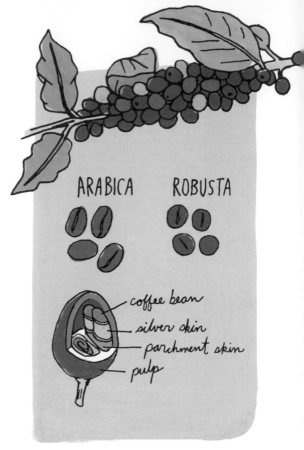

ARABICA ROBUSTA

coffee bean
silver skin
parchment skin
pulp

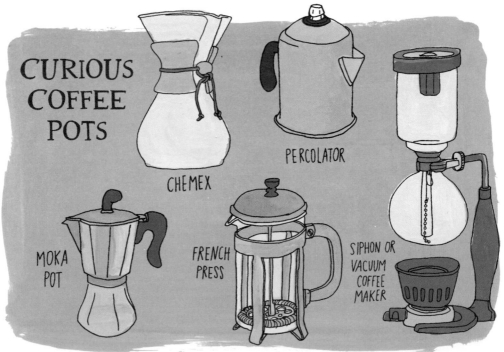

CURIOUS COFFEE POTS

CHEMEX

PERCOLATOR

MOKA POT

FRENCH PRESS

SIPHON OR VACUUM COFFEE MAKER

ESPRESSO GUIDE

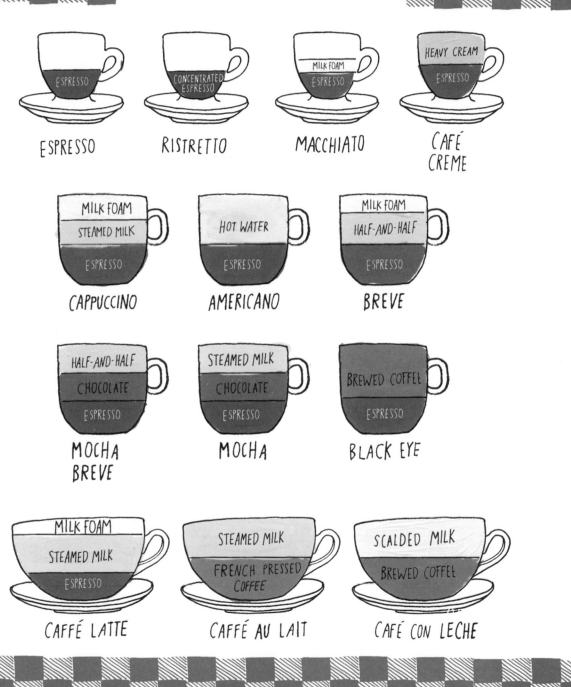

ESPRESSO — ESPRESSO

RISTRETTO — CONCENTRATED ESPRESSO

MACCHIATO — MILK FOAM / ESPRESSO

CAFÉ CREME — HEAVY CREAM / ESPRESSO

CAPPUCCINO — MILK FOAM / STEAMED MILK / ESPRESSO

AMERICANO — HOT WATER / ESPRESSO

BREVE — MILK FOAM / HALF-AND-HALF / ESPRESSO

MOCHA BREVE — HALF-AND-HALF / CHOCOLATE / ESPRESSO

MOCHA — STEAMED MILK / CHOCOLATE / ESPRESSO

BLACK EYE — BREWED COFFEE / ESPRESSO

CAFFÉ LATTE — MILK FOAM / STEAMED MILK / ESPRESSO

CAFFÉ AU LAIT — STEAMED MILK / FRENCH PRESSED COFFEE

CAFÉ CON LECHE — SCALDED MILK / BREWED COFFEE

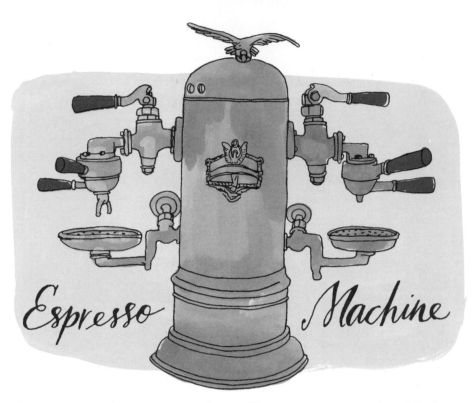

Espresso Machine

An espresso machine forces very hot pressurized water through packed coffee grinds and then a filter to produce a thick, concentrated liquid.

The first was patented in 1884 by Angelo Moriondo in Turin, Italy, but this updated design came in 1901 and was manufactured for the La Pavoni company in Milan.

CAFFEINE

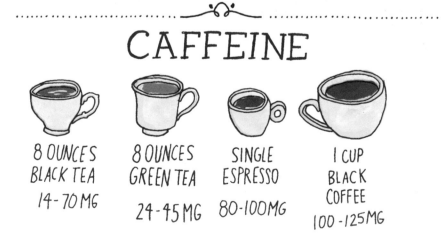

8 OUNCES BLACK TEA
14-70 MG

8 OUNCES GREEN TEA
24-45 MG

SINGLE ESPRESSO
80-100MG

1 CUP BLACK COFFEE
100-125MG

A SPOT OF TEA

Real tea — everything else is just an herbal infusion — is made from the leaves and leaf buds of just one Asian shrub: *Camellia sinensis*. Though there are many cultivars and special growing regions, all tea is harvested from just two main varieties: Chinese and Indian Assam.

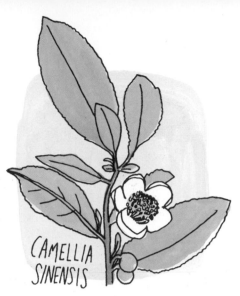

CAMELLIA SINENSIS

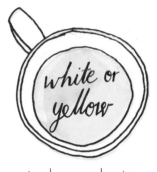

white or yellow

tender new shoots, picked only a few days per year, then quickly dried to avoid any oxidation

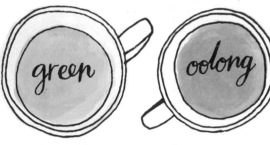

green

tea leaves that are quickly dried after harvest to avoid any oxidation

oolong

large, mature leaves allowed to oxidize slightly before they're dried

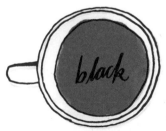

black

younger tea leaves that are bruised and fully oxidized before being dried

pu-erh

tea leaves that are allowed to ferment and age

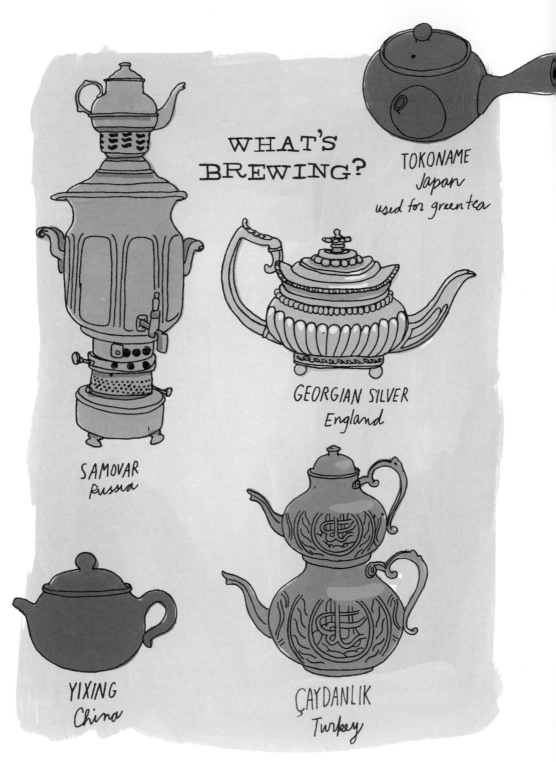

WHAT'S BREWING?

TOKONAME
Japan
used for green tea

GEORGIAN SILVER
England

SAMOVAR
Russia

YIXING
China

ÇAYDANLIK
Turkey

TEA TIME
AROUND THE WORLD

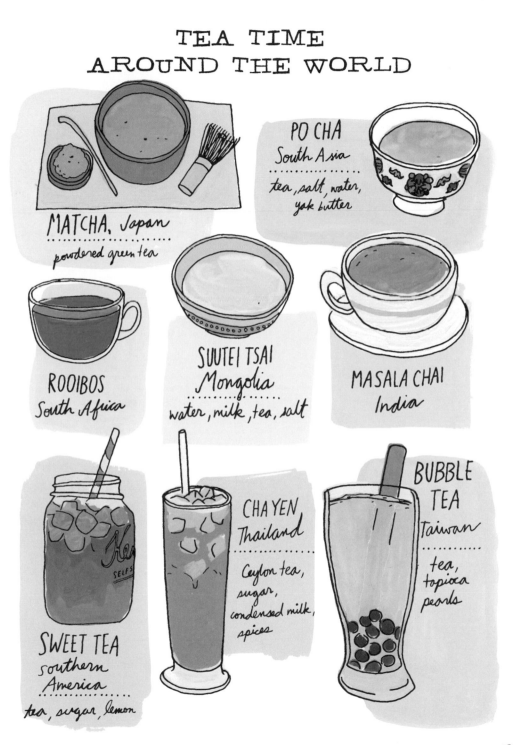

MATCHA, Japan
powdered green tea

PO CHA
South Asia
tea, salt, water, yak butter

ROOIBOS
South Africa

SUUTEI TSAI
Mongolia
water, milk, tea, salt

MASALA CHAI
India

SWEET TEA
southern America
tea, sugar, lemon

CHA YEN
Thailand
Ceylon tea, sugar, condensed milk, spices

BUBBLE TEA
Taiwan
tea, tapioca pearls

When Life Gives You Lemons...

PAPELÓN CON LIMÓN

a Venezuelan drink made with earthy, dark brown, unrefined cane sugar, water, and lime or lemon juice

LIMONANA

a mix of freshly squeezed lemon juice, spearmint leaves, and water served in the Middle East

CHANH MUỐI

Vietnamese lemonade made with whole, salt-preserved lemons or limes, sugar, and water or seltzer

ARNOLD PALMER

a 50-50 blend of lemonade and iced tea, named after an American golfer who reportedly asked for the drink; also known as a "half and half"

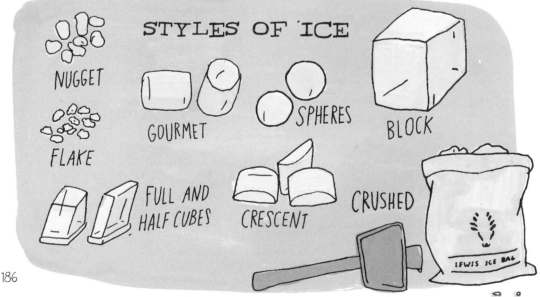

STYLES OF ICE

NUGGET

GOURMET

SPHERES

BLOCK

FLAKE

FULL AND HALF CUBES

CRESCENT

CRUSHED

LEWIS ICE BAG

Shikanjvi for Two

A spiced lemonade from the Indian subcontinent, also known as nimbu pani. Ingredients vary — try adding muddled ginger, saffron threads, or rose water along with the mint.

1 TEASPOON CUMIN POWDER
2 TABLESPOONS FRESHLY SQUEEZED LEMON JUICE
½ TEASPOON KALA NAMAK, OR INDIAN BLACK SALT
3 TABLESPOONS SUGAR
4 FRESH MINT LEAVES, OPTIONAL
1-2 CUPS LARGE ICE CUBES

1. Heat the cumin powder in a small skillet over medium to medium-high heat until it begins to smell fragrant and toasted. Remove pan from heat and set aside.

2. Pour two cups of cool water into a 1-quart mason jar with a lid.

3. Add the lemon juice, kala namak, and sugar. Cover the jar and shake until the sugar has dissolved.

4. Add two mint leaves to the bottom of each serving glass. Fill each glass with ice cubes, top with the shikanjvi, and stir until the ice has slightly melted and the drink is cold. Serve immediately, topped with more mint leaves, if desired.

FIZZY SIPS

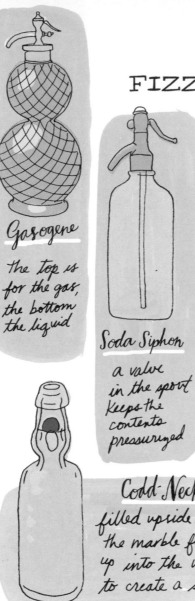

Gasogene

the top is for the gas, the bottom the liquid

Soda Siphon

a valve in the spout keeps the contents pressurized

Codd-Neck

filled upside down; the marble floats up into the well to create a seal

SELTZER WATER

The original seltzer water was actually "Selter" water, or naturally effervescent mineral spring waters from the German town of Selters. Though there are still natural sources for sparkling mineral waters, today most seltzer is man-made, thanks to a process refined by Englishman Joseph Priestley in 1767. Though it once contained minerals or salts, today it's usually just water and carbon dioxide gas. The latter, dissolved in water at a low concentration, creates carbonic acid, which is what gives seltzer, also known as carbonated water, a slightly tart flavor.

SOFT DRINK

Carbonated, flavored water with added sweeteners and flavorings, often with color, preservatives, and occasionally caffeine. Made in contrast to "hard" drinks, aka those with alcohol. Known as "pop" or "soda" in different regions of the United States.

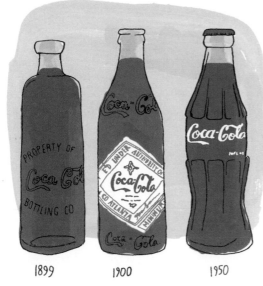

1899 1900 1950

COLA

A carbonated, flavored soft drink with caramel color and caffeine, inspired by traditional drinks that originally contained caffeine from the kola nut and cocaine from coca leaves. John Pemberton invented Coca-Cola in 1886 by making a nonalcoholic version of a coca-leaf wine that was made by a French pharmacist as early as 1863.

ROOT BEER

Originally, a noncaffeinated soft drink flavored with the bark of the root of the sassafras tree, though now more often artificial flavorings.

SARSAPARILLA

This non-caffeinated soft drink is no longer made from the sarsaparilla vine — except in Australia and the UK — but instead from sassafras and birch trees. Often also called root beer, it was once very popular in the 19th-century American West.

BIRCH BEER

Made from the sap and bark of different birch trees, the flavor and color vary depending on the locale. It is most often made in the northeast United States.

THE EQUATIONS OF FERMENTED BEVERAGES

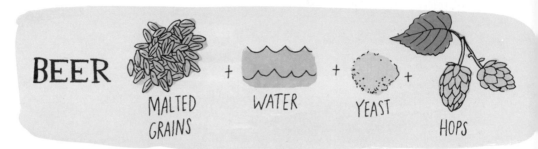

BEER MALTED GRAINS + WATER + YEAST + HOPS

ALES **vs** LAGERS

Beer is usually divided into a few main categories, depending on what kind of yeasts are used to make it. Ale yeasts work at warmer temperatures, rise to the surface during fermentation, and typically produce fruity flavors technically known as esters. Lager yeasts — a classic lager style is a pilsner — require colder temperatures and sink to the bottom.

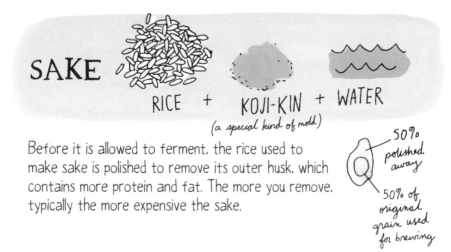

SAKE RICE + KOJI-KIN + WATER
(a special kind of mold)

Before it is allowed to ferment, the rice used to make sake is polished to remove its outer husk, which contains more protein and fat. The more you remove, typically the more expensive the sake.

50% polished away

50% of original grain used for brewing

KOMBUCHA

TEA + (YEAST+BACTERIA) + SUGAR
SCOBY

A centuries-old drink popular for its tangy flavor and healthful properties, kombucha is made by fermenting strong sweet tea with a SCOBY (Symbiotic Colony of Bacteria and Yeast).

CIDER

APPLE JUICE + YEAST

Just as for wine, the sweetest, biggest fruit does not yield the tastiest cider, which traditionally meant an alcoholic beverage rather than apple juice.

Secondary Fermentation

Fermentation creates some carbon dioxide, but that's not what makes a bottle of Champagne so bubbly. To do that, you add what's known as liqueur de tirage — a mix of wine, sugar, and yeast — to the wine as it's bottled, in a process called secondary fermentation. Also known as bottle-conditioning, a similar process is used to make some kinds of beer and cider.

191

The Basic Steps in Making Wine

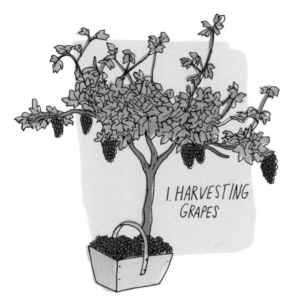

1. HARVESTING GRAPES

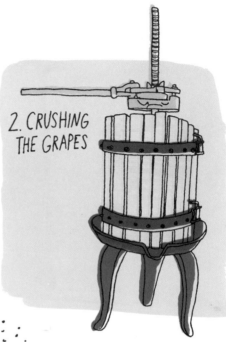

2. CRUSHING THE GRAPES

3. MACERATION

The skin, seeds and pulp of the grapes are mashed with the fermenting juice. This process leaches the tannins, color and flavor.

White wine can be made with red grapes — you just don't use the skins. For a rosé, they are kept in the macerating tub for just a few hours.

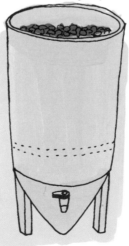

4. FERMENTATION

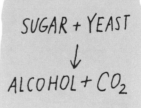

$$SUGAR + YEAST$$
$$\downarrow$$
$$ALCOHOL + CO_2$$

5. AGING

Aging a wine improves its aroma, color, and taste. Different types of vessels are used to hold the liquid during this stage.

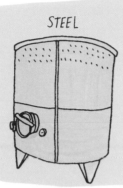

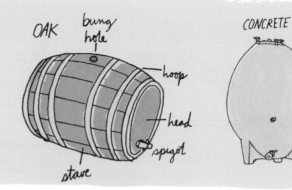

STEEL

OAK — bung hole — hoop — head — spigot — stave

CONCRETE

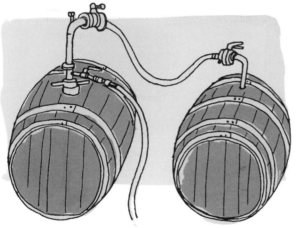

6. RACKING

Racking is moving wine from one barrel to another using gravitational pull. This process softens the tannins and brings out the aromas of the wine.

7. FILLING & CORKING

Bottles corked with synthetic corks can be stored upright. With natural cork, wines are stored on their sides so the cork doesn't dry out.

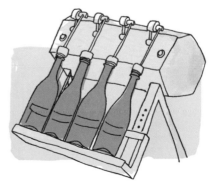

WINE TASTING

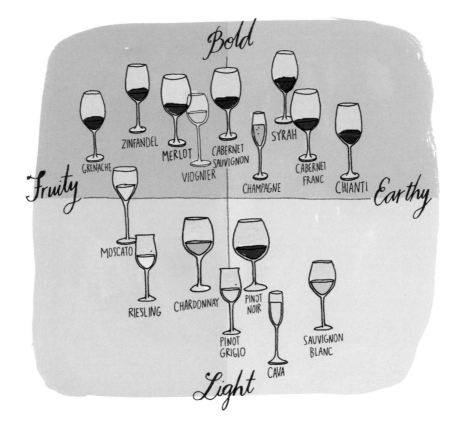

Bold

Fruity — Earthy

Light

- ZINFANDEL
- GRENACHE
- MERLOT
- VIOGNIER
- CABERNET SAUVIGNON
- SYRAH
- CHAMPAGNE
- CABERNET FRANC
- CHIANTI
- MOSCATO
- RIESLING
- CHARDONNAY
- PINOT NOIR
- PINOT GRIGIO
- CAVA
- SAUVIGNON BLANC

PARTS OF A GLASS

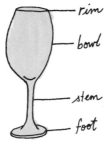

- rim
- bowl
- stem
- foot

QUICK TERMS

BODY - how a wine feels in your mouth (light, medium or full)

CRISP - the right amount of acidity

DRY - not sweet

EARTHY - tastes and smells like organic matter

FIRM - stronger tannin flavor

NOSE - the aroma

Distillation

The type of base liquid and the process of aging, often in wood barrels, affect flavor. So does distillation itself, a complex process that at the expert level is as much art as science.

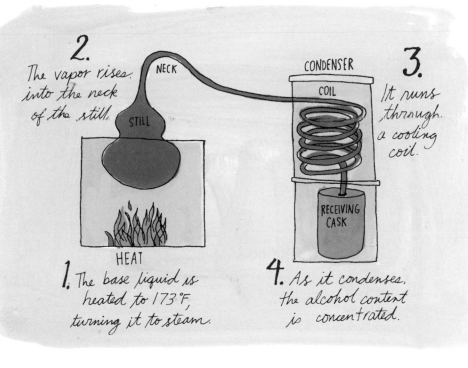

2. The vapor rises into the neck of the still.

NECK

STILL

HEAT

1. The base liquid is heated to 173°F, turning it to steam.

CONDENSER

COIL

3. It runs through a cooling coil.

RECEIVING CASK

4. As it condenses, the alcohol content is concentrated.

FERMENTED SUGARCANE OR MOLASSES = RUM
CORN, WHEAT, AND RYE = WHISKEY
FERMENTED AGAVE JUICE = TEQUILA
FERMENTED POTATOES = VODKA

GLASSWARE

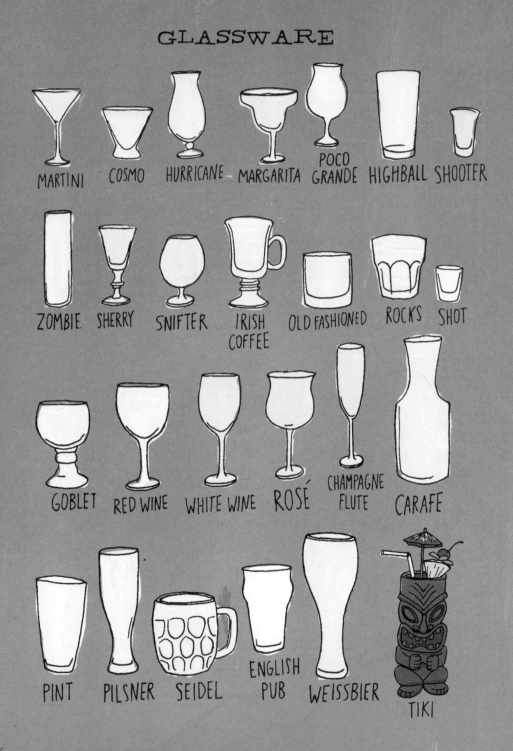

MARTINI COSMO HURRICANE MARGARITA POCO GRANDE HIGHBALL SHOOTER

ZOMBIE SHERRY SNIFTER IRISH COFFEE OLD FASHIONED ROCKS SHOT

GOBLET RED WINE WHITE WINE ROSÉ CHAMPAGNE FLUTE CARAFE

PINT PILSNER SEIDEL ENGLISH PUB WEISSBIER TIKI

The Cocktail Maker's Toolkit

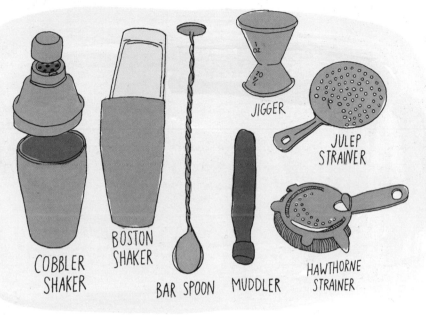

COBBLER SHAKER

BOSTON SHAKER

BAR SPOON

MUDDLER

JIGGER

JULEP STRAINER

HAWTHORNE STRAINER

Two Mixed Drinks Every Adult Should Know:

MANHATTAN

2 OUNCES RYE WHISKEY
1 OUNCE SWEET VERMOUTH
2 DASHES ANGOSTURA BITTERS

MARTINI

1 OUNCE DRY VERMOUTH
4 OUNCES GIN

CHAPTER 9

Sweet Tooth

Common Cakes

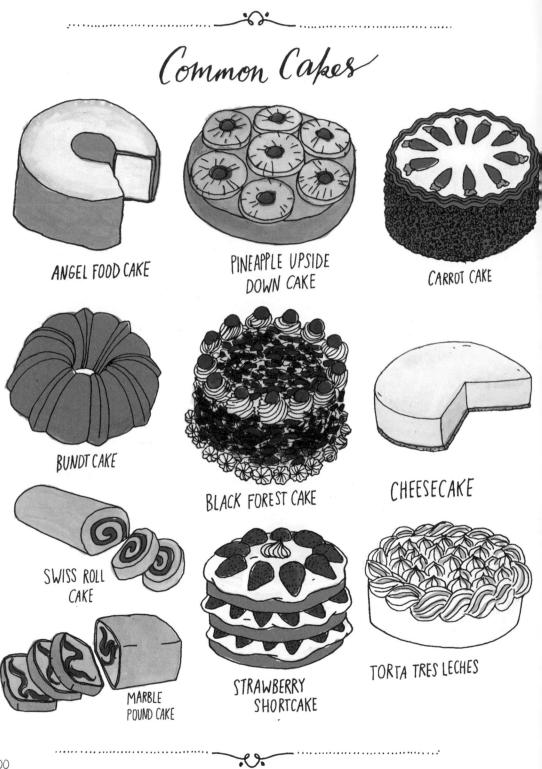

ANGEL FOOD CAKE

PINEAPPLE UPSIDE DOWN CAKE

CARROT CAKE

BUNDT CAKE

BLACK FOREST CAKE

CHEESECAKE

SWISS ROLL CAKE

MARBLE POUND CAKE

STRAWBERRY SHORTCAKE

TORTA TRES LECHES

CAKE-MAKING TERMS

cake flour — made from soft, finely milled, highly bleached, low-protein wheat, which results in cakes with a lighter texture

fondant — a paste-like sugar icing that can be applied in smooth sheets and easily molded

ganache — silky smooth frosting made from a mix of dark or white chocolate and heavy cream.

buttercream — all-purpose frosting made from a blend of butter or shortening and confectioner's sugar beaten until smooth

royal icing — hard white icing made from beaten egg whites, confectioner's sugar, and lemon juice

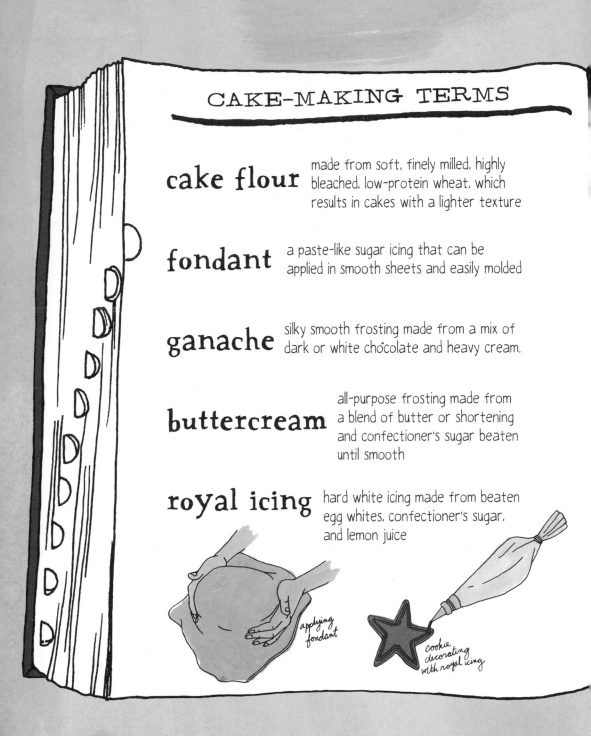

applying fondant

cookie decorating with royal icing

WE ALL SCREAM FOR ICE CREAM

AMERICAN, NEW YORK, OR PHILADELPHIA-STYLE

ice cream made with just sugar, milk, and cream

FRENCH-STYLE

ice cream based on a custard, or a heated blend of milk and eggs

SOFT SERVE

similar to American-style ice cream, but made with less butterfat, churned with much more air, and served at a warmer temperature and softer texture

FROZEN CUSTARD

similar to soft serve, but made with more butterfat and the addition of egg yolks; typically churned with less air

GELATO

Italian version, made with less fat and churned at a lower speed, resulting in a dense consistency

KULFI

Indian-style frozen, dairy-based dessert that is not ice cream but frozen milk, sugar, and water

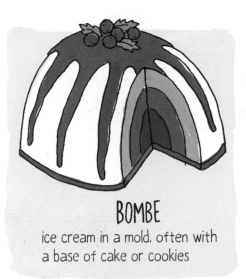

BOMBE

ice cream in a mold, often with a base of cake or cookies

BAKED ALASKA

a layer of cake topped with ice cream and covered with meringue, then quickly browned in a very hot oven

20TH CENTURY ASIAN ICE SHAVING MACHINE

Shaved Ice

Served throughout the world in various forms, this treat originated in Japan, where it has been made for 1500 years and is called kakigōri. The basic formula is shaved or chipped ice saturated with flavored syrups; toppings include condensed milk, red beans, corn kernels, and jellies.

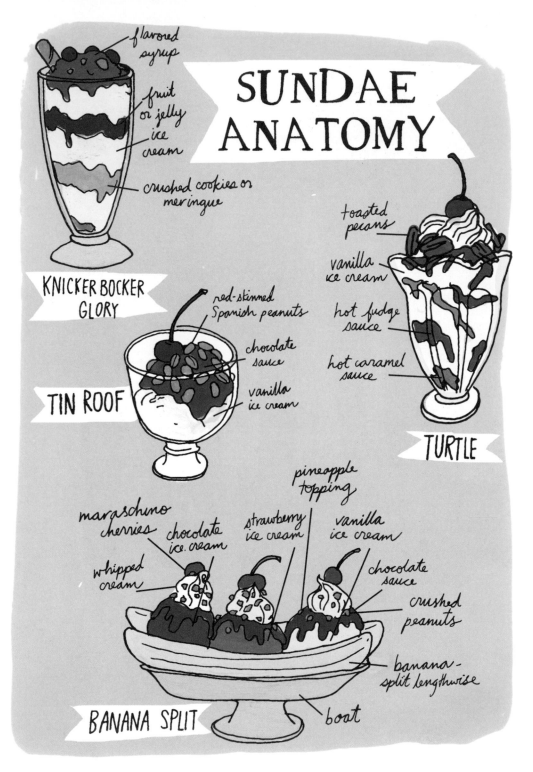

SUNDAE ANATOMY

KNICKER BOCKER GLORY
- flavored syrup
- fruit or jelly
- ice cream
- crushed cookies or meringue

TIN ROOF
- red-skinned Spanish peanuts
- chocolate sauce
- vanilla ice cream

TURTLE
- toasted pecans
- vanilla ice cream
- hot fudge sauce
- hot caramel sauce

BANANA SPLIT
- pineapple topping
- maraschino cherries
- chocolate ice cream
- whipped cream
- strawberry ice cream
- vanilla ice cream
- chocolate sauce
- crushed peanuts
- banana-split lengthwise
- boat

COOKIES

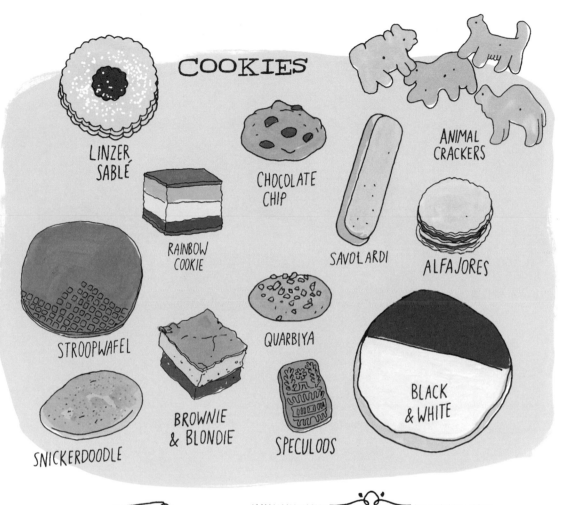

LINZER SABLÉ

CHOCOLATE CHIP

ANIMAL CRACKERS

RAINBOW COOKIE

SAVOLARDI

ALFAJORES

STROOPWAFEL

QUARBIYA

SNICKERDOODLE

BROWNIE & BLONDIE

SPECULOOS

BLACK & WHITE

Gingerbread itself — a stiff dough originally sweetened with honey and flavored with ginger and other spices — dates back several centuries. The craft of forming it into elaborately decorated shapes arose in Europe during the 12th and 13th centuries. German bakers in the 16th century developed the craft into an art form practiced by professional guilds.

How Chocolate Is Made

cacao beans

1. HARVEST

Ripe pods are cut from cacao trees and split open like coconuts, revealing the white pulp that contains the cacao beans.

pods

banana leaves

2. FERMENTATION

The pods and pulp are fermented to develop flavor and then dried and sorted for shipping to chocolate makers. The beans are now called cocoa beans.

3. ROASTING

Beans are roasted to the chocolate maker's specifications, revealing different flavors and aromatics.

4. CRACKING & WINNOWING

The roasted beans are broken into pieces and the papery outer shell is blown off with fans. The small pieces of cocoa bean are known as nibs and are sometimes used in desserts and as decoration.

nib

5. GRINDING & CONCHING

conching machine

Nibs are ground to produce both cocoa liquor, the essence of chocolate, and cocoa butter, a pure fat; the remaining dry solids are used to make cocoa powder. Conching is the process of heating and mixing cocoa liquor, cocoa butter (or for cheaper candy, another fat), and sugar for hours or even days to create a smooth, flavorful blend.

6. TEMPERING

Before being poured into molds, chocolate is repeatedly heated and cooled, which results in a bar or bon bon that is shiny and glossy, rather than soft and crumbly.

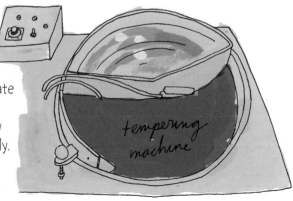

tempering machine

—mold

WORLDLY TREATS

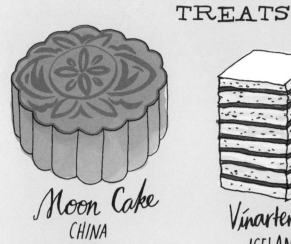

Moon Cake
CHINA

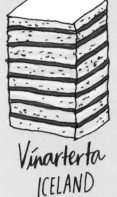

Vínarterta
ICELAND

Kokis
SRI LANKA

Sakuramochi
JAPAN

Maple Candy
CANADA

Zefir
RUSSIA

Mujigae-tteok
KOREA

Petit Fours
FRANCE

Brigadeiro
BRAZIL

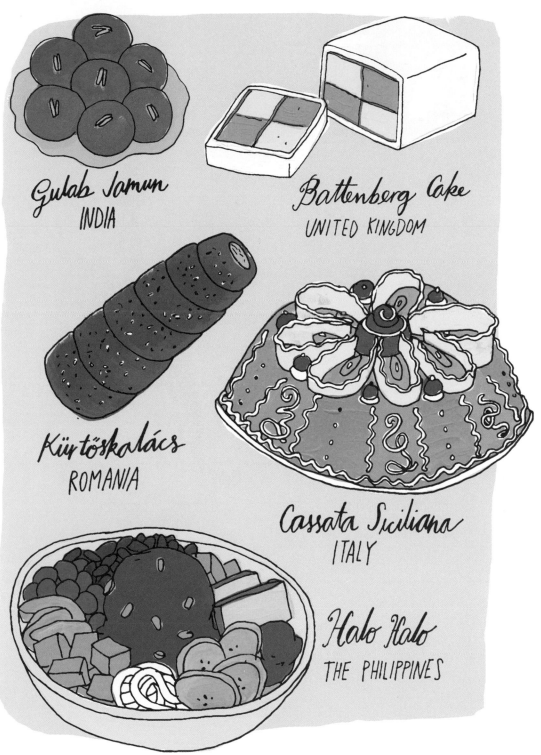

Gulab Jamun
INDIA

Battenberg Cake
UNITED KINGDOM

Kürtőskalács
ROMANIA

Cassata Siciliana
ITALY

Halo Halo
THE PHILIPPINES

A SPOONFUL OF SUGAR

In the United States, dark brown or light brown sugar is most commonly made from refined white sugar crystals with added molasses.

Demerara, turbinado, and muscovado sugars — sometimes called "raw" sugars — are made by retaining some of the molasses naturally found in sugarcane as the sugar is processed. These vary in crystal size and intensity of flavor.

The most deeply flavored sugars come from evaporated, unprocessed sugarcane juice, rich with molasses. Depending on the country, this is called panela, rapadura, jaggery, piloncillo, kokuto — all of which come in dense blocks, rather than crystals — or unrefined whole cane sugar.

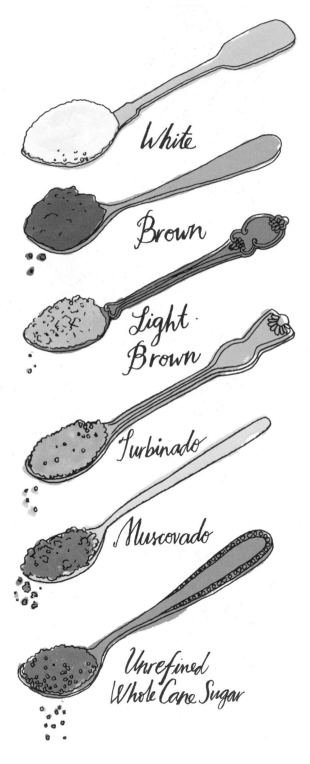

White

Brown

Light Brown

Turbinado

Muscovado

Unrefined Whole Cane Sugar

Homemade Butterscotch Sauce

While the term caramel refers to candies and sauces made by browning white sugar, butterscotch refers to those made with brown sugar. (Toffee, on the other hand, is butterscotch candy that has been cooked to the hard-crack stage.) While true butterscotch should contain butter, today most recipes for butterscotch or caramel both contain butter and also milk or cream.

4 TABLESPOONS UNSALTED BUTTER
1 CUP DARK BROWN SUGAR
3/4 CUP HEAVY CREAM
1/2 TEASPOON SALT

1. In a heavy-bottomed saucepan, melt the butter over medium-low heat. When it begins to soften, add the sugar and stir until all the crystals are moistened.

2. Cook the butter-sugar mixture, stirring occasionally, until it begins to bubble and thicken, just a few minutes.

3. Whisk in the cream, then bring the mixture to a simmer and cook, whisking occasionally, until the mixture is thick and glossy.

4. Whisk in the salt, adding more to taste. Let cool completely before refrigerating for up to two weeks.

 # CANDY

A lot of candies are made by boiling sugarwater until it reaches a desired consistency. The ratio of sugar to water and the length of the boil affect the process, but the textures of candy products progress from syrup to soft and chewy to hard and finally, brittle. The correct stage is judged by how a spoonful of the hot mixture reacts when dropped into cold water, from forming a soft ball to creating brittle threads.

SUGAR STATE	TEMPERATURE	PERCENT SUGAR	EXAMPLE
SOFT BALL	234-241°F	85%	FUDGE
FIRM BALL	244-248°F	87%	SOFT CARAMEL
HARD BALL	250-266°F	90%	GUMMY BEARS
SOFT CRACK	270-289°F	95%	SALTWATER TAFFY
HARD CRACK	295-309°F	99%	LOLLIPOPS

Making Hard Candy

AFTER BOILING, THE CANDY IS...

1. COOLED ON A SURFACE

2. PULLED ON A HOOK

3. STRETCHED

4. CHOPPED INTO PIECES

CANDY BUTTONS

In an
OLD-
FASHIONED
Candy Shop

MARY JANES

CANDY NECKLACE

WAX BOTTLES

Bite off the top, suck out the flavored syrup, then chew the wax like gum.

FREE GREAT FLAVORS FAT FREE
Necco Assorted ® The original candy wafer
American Value

Original flavors included clove, cinnamon, wintergreen, and licorice.

COTTON CANDY

A form of "spun sugar," where liquified sugar ejected out of tiny holes immediately solidifies into thin strands.

LICORICE

Traditionally, this candy was flavored with the extract of the roots of the licorice plant.

BUTTERMINTS

With their famously chalky texture, these have been manufactured since 1893.

ATOMIC FIREBALLS

CANDY CIGARETTES

STALLION
CANDY

PASTRIES

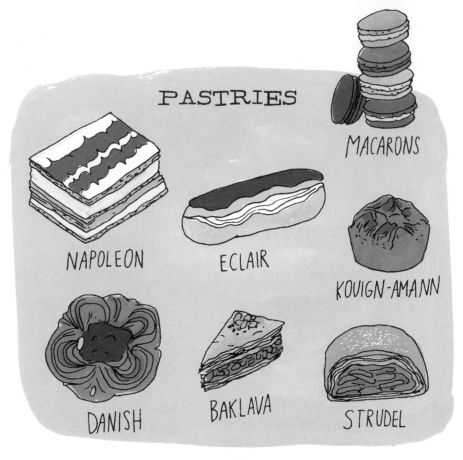

MACARONS

NAPOLEON

ECLAIR

KOUIGN-AMANN

DANISH

BAKLAVA

STRUDEL

Making Puff Pastry

"Laminate" is the professional term to describe the process whereby butter or fat is repeatedly folded and smeared into a dough, resulting in a flaky, crispy, multi-layered texture.

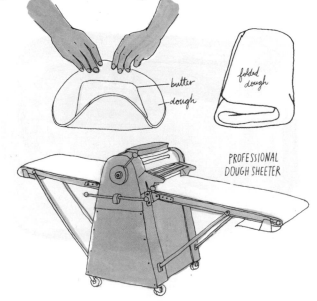

butter

dough

folded dough

PROFESSIONAL DOUGH SHEETER

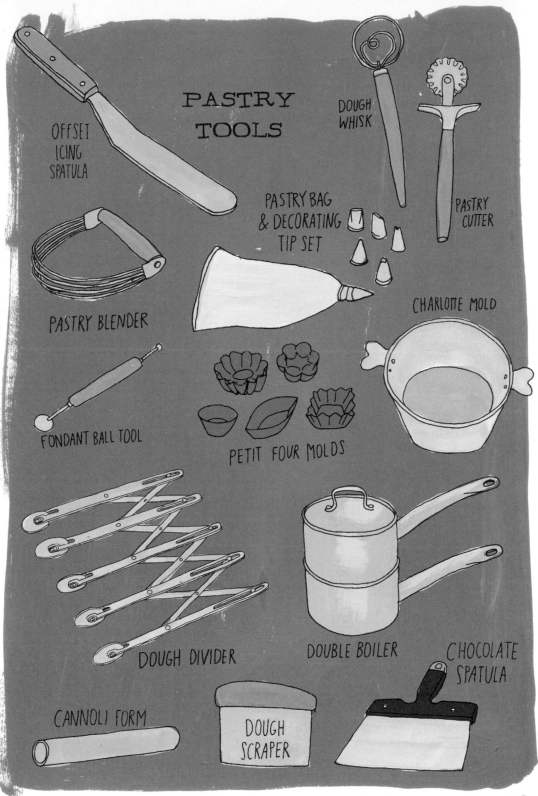

PASTRY TOOLS

OFFSET ICING SPATULA

DOUGH WHISK

PASTRY CUTTER

PASTRY BAG & DECORATING TIP SET

PASTRY BLENDER

CHARLOTTE MOLD

FONDANT BALL TOOL

PETIT FOUR MOLDS

DOUGH DIVIDER

DOUBLE BOILER

CHOCOLATE SPATULA

CANNOLI FORM

DOUGH SCRAPER

SOFT SWEETS
AROUND THE WORLD

WHITE NOUGAT

Chewy confections made with roasted nuts, whipped egg whites, candied fruit, and sugar or honey. A star on its own in Italy and Spain, in the US it is better known as the filling for candy bars.

HALVA

This dense Middle Eastern, Asian, and southeastern European sweet is made from a paste of many different kinds of ingredients, including semolina, sesame seeds, fruits, or eggs and nuts.

MARZIPAN

A paste of ground almonds, sugar, and sometimes egg, which is colored and molded into elaborate shapes. Made around the world and known by many names, marzipan sweets are often a specialty at Christmas.

DODOL

A toffee-like sweet made from coconut milk, natural brown sugar, and rice flour, it is sold throughout southeast Asia in dozens of flavors.

MARSHMALLOW

Sugar is boiled until all the water is gone, mixed with gelatin or gum arabic, and then added to beaten egg whites. A form of this confection, thickened with the sap of the marshmallow plant (*Althaea officinalis*), was made in ancient Egypt.

S'mores

graham cracker

marshmallow

chocolate

marshmallow plant

BARFI

South Asian sweets made by cooking condensed milk and sugar until thick, then cooling it and cutting into small pieces. It comes in a variety of shapes and flavors, including carrot, mango, coconut, pistachio, cardamom, and rose water.

Known as *lokum* in Turkish, this jelly candy was originally made during the Ottoman Empire, which fostered its spread throughout that region. Made of sugar syrup cooked with a thickener, the squares are often flavored with rose water and dusted with powdered sugar.

TURKISH DELIGHT

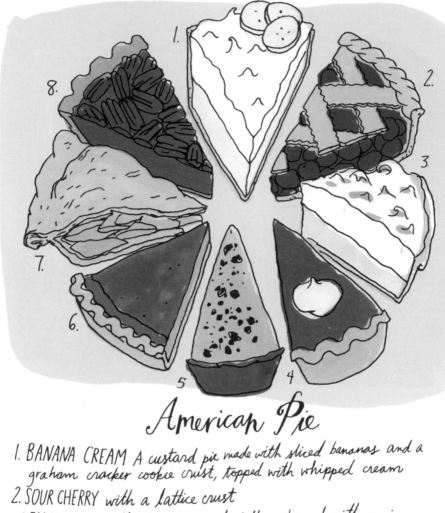

American Pie

1. BANANA CREAM A custard pie made with sliced bananas and a graham cracker cookie crust, topped with whipped cream
2. SOUR CHERRY with a lattice crust
3. LEMON MERINGUE Lemon curd filling topped with meringue (whipped egg whites and sugar)
4. CHOCOLATE CHESS Southern-style custard pie flavored with cocoa powder and thickened with cornmeal
5. GRASSHOPPER A mint-flavored, whipped cream-filled pie with a crushed chocolate cookie crust.
6. BEAN A sweet custard pie made with mashed navy beans
7. DOUBLE CRUST APPLE Best made with tart baking apples that retain their texture
8. PECAN Filled with a mix of eggs, butter, dark corn syrup or molasses and whole pecans

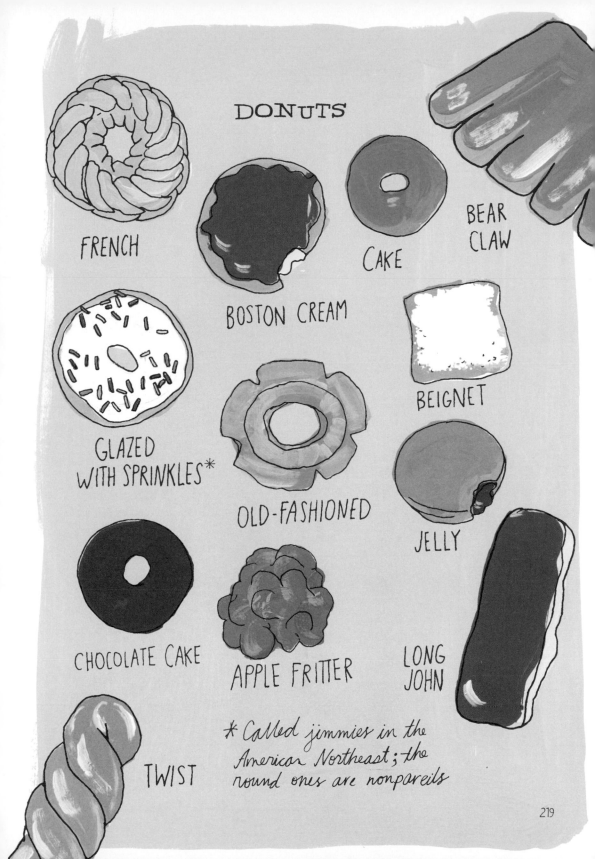

DONUTS

FRENCH

BOSTON CREAM

CAKE

BEAR CLAW

GLAZED WITH SPRINKLES*

OLD-FASHIONED

BEIGNET

JELLY

CHOCOLATE CAKE

APPLE FRITTER

LONG JOHN

TWIST

* Called jimmies in the American Northeast; the round ones are nonpareils

THE FORTUNE COOKIE

The history of this crisp little cookie that contains a paper fortune — given out as an after-dinner gift in restaurants run by Chinese expatriates around the world — is a murky one.

A handful of California bakers, most of them Japanese, claimed to have been the first to bake them in the United States in the 1900s, and indeed a similar cookie has long been made in Kyoto. One thing we do know: it wasn't traditionally consumed in China.

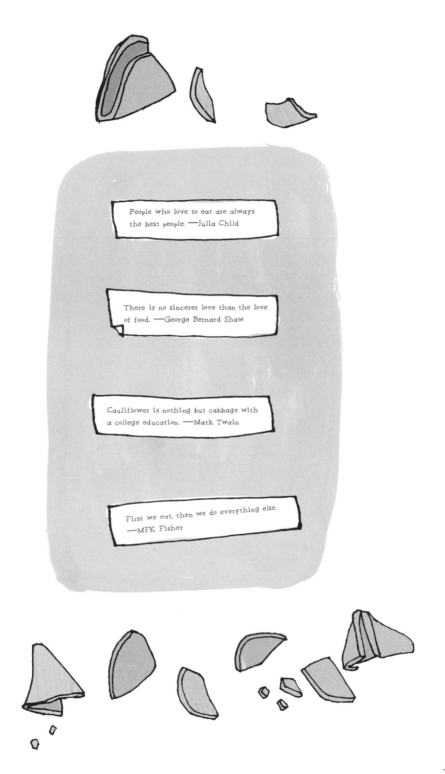

People who love to eat are always the best people. —Julia Child

There is no sincerer love than the love of food. —George Bernard Shaw

Cauliflower is nothing but cabbage with a college education. —Mark Twain

First we eat, then we do everything else. —MFK Fisher

THANK YOU

These books take longer than a year to finish and so much research, editing, drawing, painting and laying out happens with the help of so many other people.

First, I have to thank Rachel Wharton, my partner on this book. I couldn't have asked for a better person to work with. She made it easy and fun and researched and wrote such fascinating information to make this come together.

My editor, Lisa Hiley, who is always patient and helps me stay on track. Also all of the other wonderful collaborators I have at Storey. It's been so many years working with them, I think I can call them my friends: Deborah Balmuth, Alethea Morrison, Maribeth Casey, and everyone else at that welcoming office.

Eron Hare, my truly amazing assistant, who sat by my side painting, helping with ideas and organizing me. I couldn't have finished without his help.

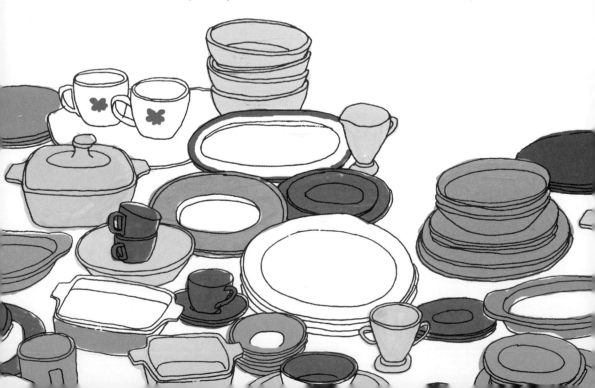

Mira Evnine, who helped me with intial brainstorms and connected me to the food world.

Jim Datz, for taking me on expertly led Asian market excursions.

Jenny, "pro kale massager," and Matt, "pro pastry eater," who help with everything I do in work and life.

Gretta Keene, for giving me the best tools to get me through the biggest obstacles even when they get way too overwhelming.

My parents and sister, who continue to be the best, most supportive family.

Pirjo and Esko Mustonen, who welcomed me into their home to learn the traditional cooking of Finland. And Ari Korhonen, for letting me come pick strawberries.

And Santtu Mustonen, who this book is dedicated to, who taught me how to really eat and is just all-around inspiring.

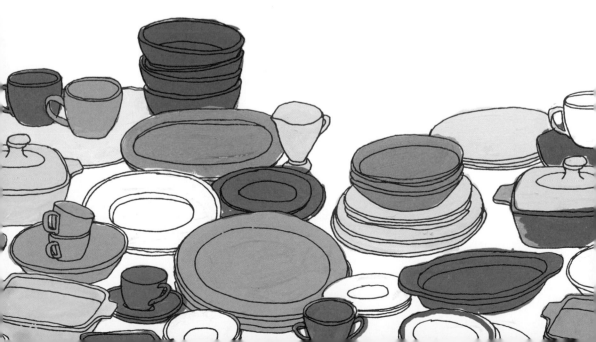